BATTERSEA
THROUGH TIME

Simon McNeill-Ritchie
& Ron Elam

AMBERLEY PUBLISHING

About the Authors

Simon McNeill-Ritchie lived for twenty years in the Battersea area, where he was a frequent public speaker on local history and deputy editor of the *Wandsworth Historian*, the much-respected journal of the Wandsworth Historical Society. He also served on both the London and Middlesex Archaeological Society's Council and Greater London Local History sub-committee. Simon has published two books, a DVD and several articles about aspects of local history in the area. He has an Advanced Diploma in Local History and is currently studying for a PhD in History at the University of Cambridge.

Ron Elam is a well-known local historian. He has collected many thousands of views of the streets of London showing life in the early years of the 1900s. His speciality is the areas of inner South and South West London. He also has a considerable number of pictures of many others parts of Greater London.

For Annelisa, Susannah and Tom – my present and future, that they may share my past

For my grandchildren, Baxter and Isabella

First published 2014

Amberley Publishing
The Hill, Stroud, Gloucestershire, GL5 4EP
www.amberley-books.com

Copyright © Simon McNeill-Ritchie & Ron Elam, 2014

The right of Simon McNeill-Ritchie & Ron Elam to be identified as the Authors of this work has been asserted in accordance with the Copyrights, Designs and Patents Act 1988.

ISBN 978 1 4456 3430 2 (print)
ISBN 978 1 4456 3437 1 (ebook)

British Library Cataloguing in Publication Data.
A catalogue record for this book is available from the British Library.

Typesetting by Amberley Publishing.
Printed in Great Britain.

Introduction

The place we now call Battersea has existed in records from at least as far back as the seventh century. In spite of its close proximity to London, however, it remained little more than a village surrounded by unbroken countryside until surprisingly recently. From the mid-eighteenth century, a small number of large villas began to appear around Clapham Common, and the first signs could be discerned of the industrial landscape that would later characterise the riverside boundary with the Thames. Nevertheless, by far the greater part of Battersea was given over to agriculture and market gardening, as the names of some of the main thoroughfares, such as Lavender Hill and Nightingale Lane, still bear witness.

Then, in the mid-nineteenth century, the construction of bridges across the Thames, providing easy access from the densely populated areas of Chelsea and Westminster to the north, and the arrival of the railways from the south and west, saw the population swell tenfold in just thirty years between 1851 and 1881. With it came the demand first for housing, then shops, services, industry and employment. By the beginning of the twentieth century, Battersea had turned its back on its rural roots and was now a fully fledged suburb of the City.

The influx of the labouring classes brought in its wake trade unionism and a political radicalism that was personified by its MP from 1892 to 1918, John Burns, the first Labour representative to hold a seat in the Cabinet and reflected in the former Battersea Borough Council motto: *Non mihi, non tibi, sed nobis* ('Not for me, not for you, but for us'). The rapid gentrification of many of the same areas since the 1990s, and the Conservative hold over local government in a way reminiscent of its modern beginnings, is a vivid reminder that there is a cycle to human affairs as in all forms of nature.

Battersea is a large district of over 2,000 acres that today makes up about one quarter of the London Borough of Wandsworth. Broadly triangular in shape, the northern boundary begins to the east of the

power station, Battersea's most iconic building, and follows the Thames westwards almost as far as Wandsworth Bridge. There it turns south across York Road and up onto St John's Hill, where it briefly follows the South Circular, loops around the east edge of Spencer Park and crosses the railway from Wimbledon into the playing fields of Emanuel School. From here, the boundary continues south through Wandsworth Common down as far as the intersection between St James's Drive and Trinity Road, bounces back northwards to Wandsworth Common rail station, and then heads eastwards along Nightingale Lane. Finally, it runs north across Clapham Common, over Lavender Hill and down Queenstown Road, before starting a sweep north-east around the former New Town area and Nine Elms to join the river once more.

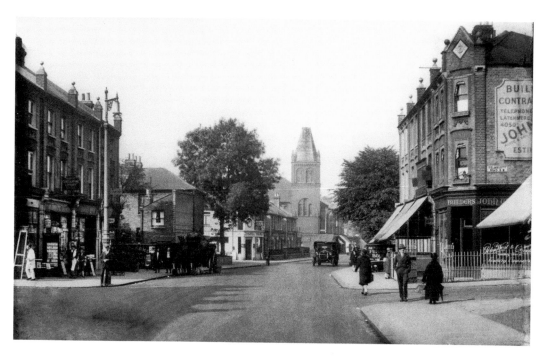

Northcote Road (South)

Running along the floor of a shallow valley, Northcote Road is the spine connecting long ribs of terraced streets that traverse it, 'between the commons' of Clapham and Wandsworth. It takes its name from Sir Stafford Northcote, Chancellor of the Exchequer and leading Tory politician at the time of its development. In recent years, the influx of upwardly mobile city professionals and a baby boom unparalleled in Europe has given rise to a new nickname: Nappy Valley. The Baptist church, visible on the left, was completed in 1889 but, typical of the time, is now a nursery school.

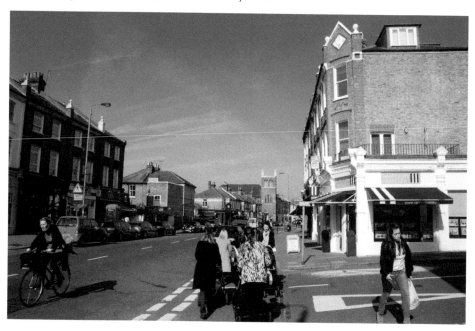

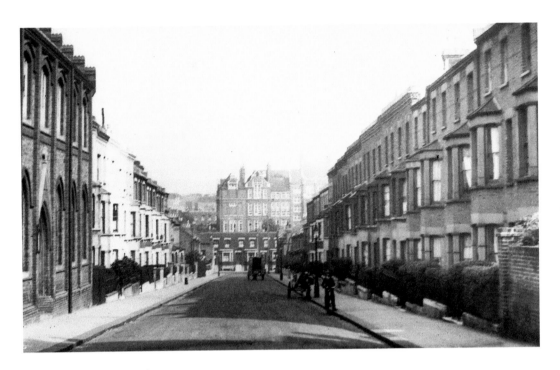

Darley Road/Cobham Close

Darley Road was typical of the terraced houses off Northcote Road until it was demolished in the 1960s and rebuilt as part of the Chatham Road West scheme, the area's only clearly discernable public housing. The original plan was scaled back to the low-density development that now lies below its taller neighbours and lends St Michael's church on the left – an early experiment in cheap, low-key church building – an undeserved hauteur. Until 2008, it was the site of the Bolingbroke Arms, built in 1855 and the first pub 'between the commons'. Belleview School, opened in 1877, stands in the distance.

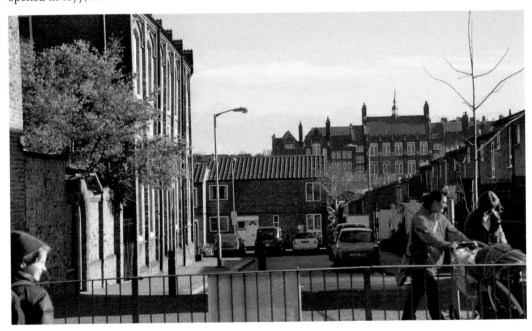

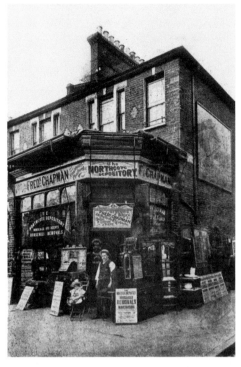

Chapman's Depository, No. 69 Northcote Road
The area around Northcote has always been residential in character, and although approval to build this road was given in 1869, it was only after it became a public thoroughfare in 1891 that shops began to appear along it. Many, such as Frederick Chapman's Northcote Depository, provided services aimed at new residents, including an estate and lettings agency, removals, storage, decorating and furnishings. Today, Northcote Road is renowned for the quality and variety of its shops and restaurants, providing residents and visitors alike with a full range of services.

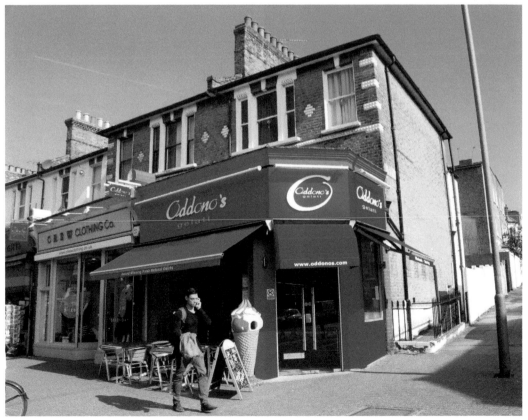

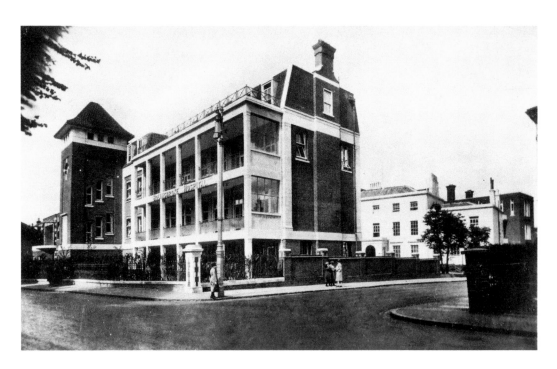

Bolingbroke Hospital/Academy, Bolingbroke Grove

In 1876, the Vicar of St Mary's church, the Revd J. Erskine Clarke, negotiated the purchase from Viscount Bolingbroke of one of the original buildings in Five Houses Lane (now Bolingbroke Grove) to convert into a much-needed hospital, which opened four years later. The original house can be seen behind the new frontage looking over Wandsworth Common, prior to its demolition in 1937. The hospital closed in 2007 and the building reopened in September 2012 as the Bolingbroke Academy, an independent secondary school run by the educational charity ARK.

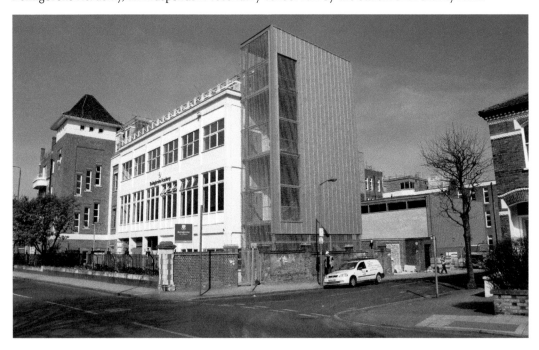

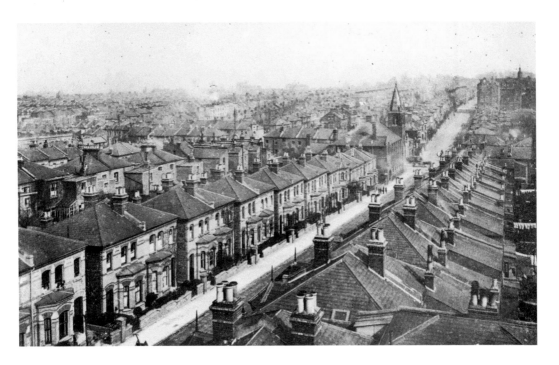

Wakehurst Road

Taken from the roof of Bolingbroke Hospital/Academy, these photographs show how Wakehurst Road is typical of the roads that run down to Northcote Road and back up the slope on the other side. While the terraced houses here have been extensively renovated inside, unlike much of Battersea, their outward appearance has changed very little – with the notable exception of the lines of cars parked in the road.

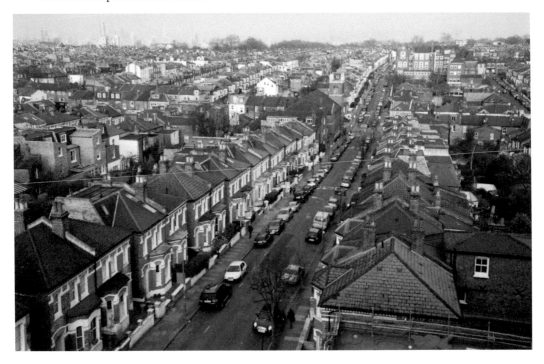

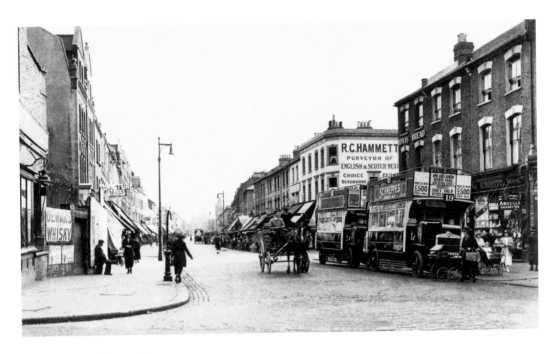

Northcote Road (North)

Before the first shops appeared, unlicensed costermongers and street traders set up noisy street markets from the 1880s. In the ensuing decade, bitter arguments frequently broke out between them and the newly emergent shopkeepers in Northcote and St John's Roads, and fights were a common occurrence outside Bolingbroke Hall, the home of the Battersea Parliament, an open debating society that stood where the supermarket is now, just beyond the lamp post on the left. Today, the costermongers have been replaced by florists, artisan bakers and occasional French markets.

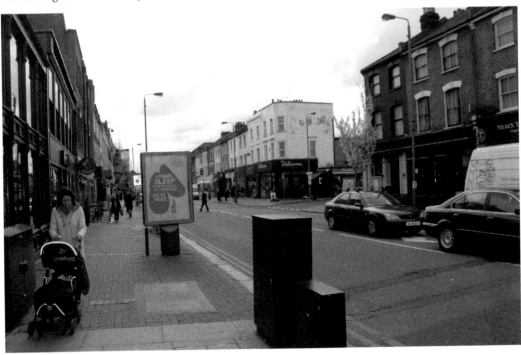

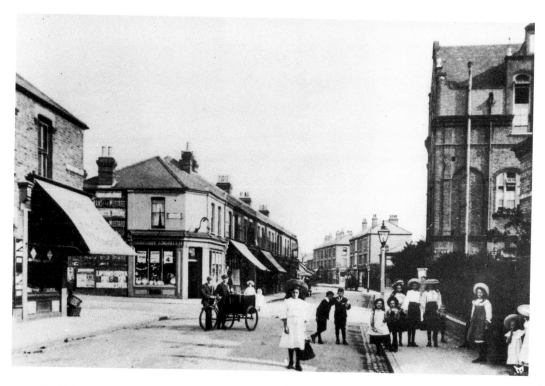

Webb's Road

Named after Charles Webb, who lived on Battersea Rise and whose family owned much of the land here for some forty years during the mid-nineteenth century. The road runs parallel with Northcote Road and Bolingbroke Grove and marks the eastern end of many of the lateral roads. After the death of Webb's widow in 1881, however, Wakehurst and several other roads were extended eastwards to Clapham Common. The parade of shops on the left was built in 1888.

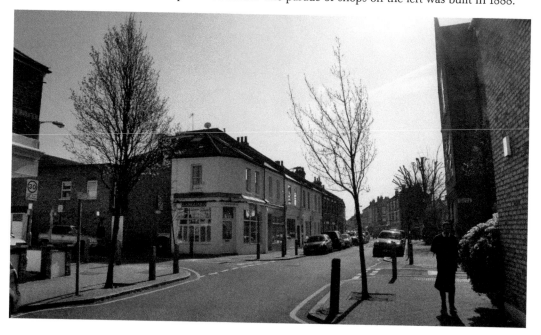

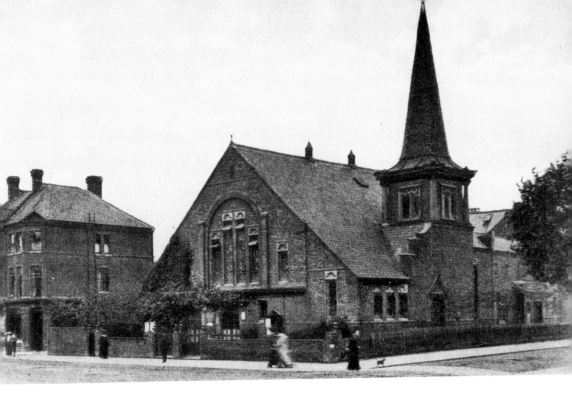

St Andrew's Church, Battersea Rise

The original Presbyterian church dated from 1896. The church buildings fell into disuse as a result of bomb damage until they were partially rebuilt in 1953. A fire in 1977 led to the removal of the tower and spire and it was eventually decided to replace the entire building. The present church, with its distinctive new tower and spire, was completed in 2002.

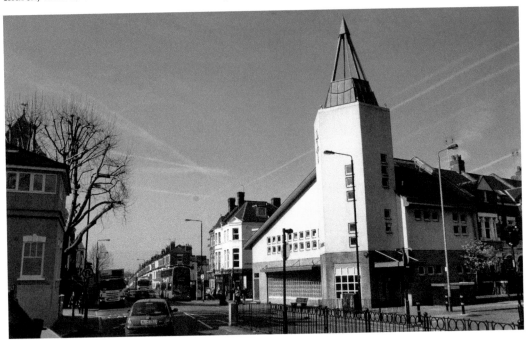

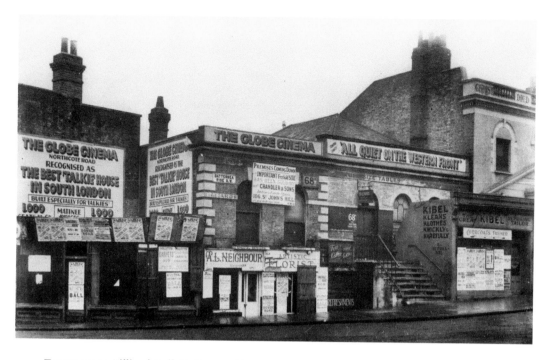

Temperance Billiard Hall, Battersea Rise

The Temperance Billiard Hall was built in 1922 as part of a movement to separate this popular game from its traditional venue, the pub. According to a plaque above the present entrance, it housed seventeen tables. For fifteen years from 1967, the hall was a Mecca bingo hall, before reverting to something close to its original purpose as a snooker hall. The building was eventually demolished in 1995 and – ironically, given its origins – replaced with a pub, currently called The Goat.

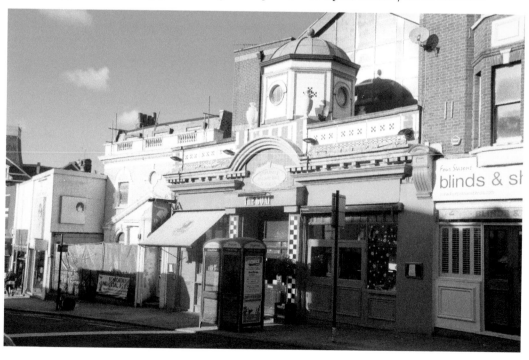

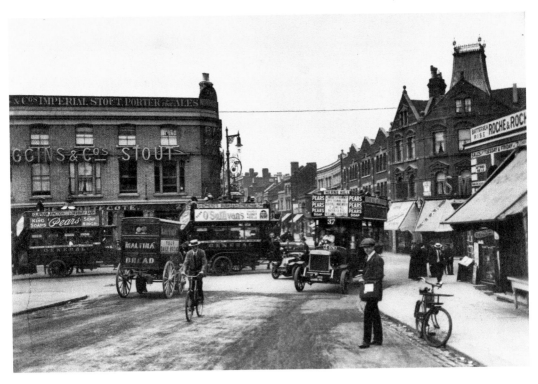

The Northcote Public House and Battersea Rise (West)

Built as the Northcote Hotel along with the initial houses and shops when Northcote Road was first laid out after 1869, for almost 150 years The Northcote has weathered the wane and wax of the area's fortunes. Today it is just as popular as ever, surrounded by a lively commercial and entertainment district. Now part of the South Circular ring road, the traffic up Battersea Rise is as constant as it is slow, and buses still pour out of St John's Road on their way across South London.

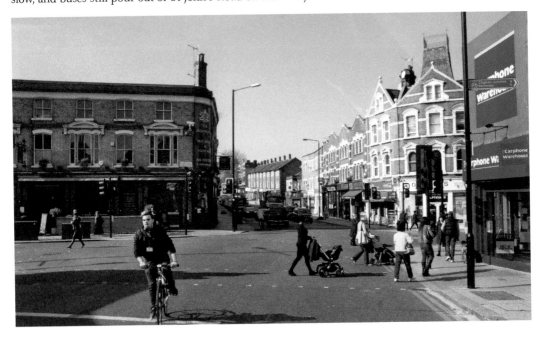

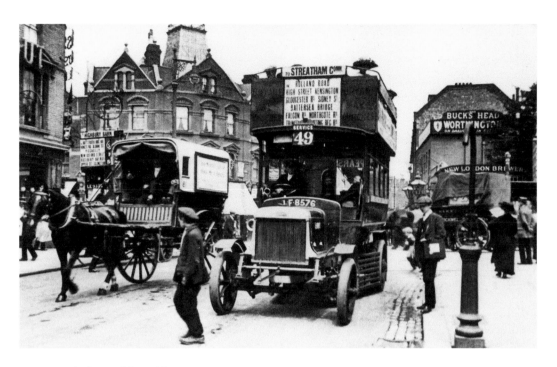

St John's Road (South)

In contrast with the boisterous nature of the street markets in Northcote Road, the shops in St John's Road behind the bus presented a pleasing, harmonious aspect. Before 1914, most shops were run by independent sole traders, and in addition to food and clothing the street was renowned for its drapery stores. By the interwar period, however, they were being steadily replaced by national chain stores and today all but a handful of independent shops have been squeezed out.

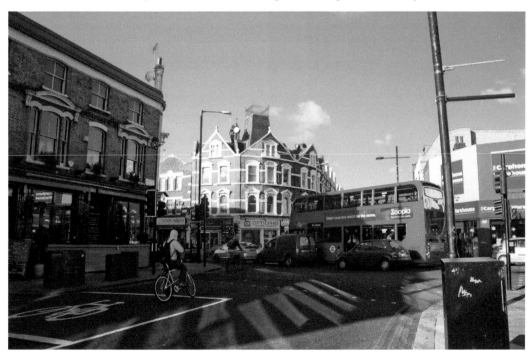

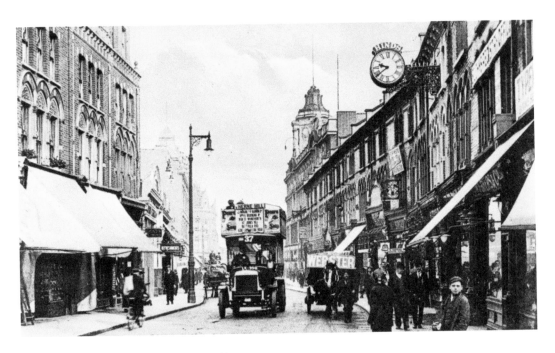

Parade of Shops, St John's Road (North)

Plenty of shops already lined the lengths of both Battersea Park Road and York Road, before those at the east end of both roads were demolished to make way for public housing. However, they were spread over more than 2 miles across the entire breadth of the borough. The concentration of commuters around Clapham Junction, followed by the arrival of Battersea's only department store, Arding & Hobbs (seen here in the centre of this photograph) established St John's Road and its neighbouring streets as the area's principal shopping centre. The shops here were among the main victims of the urban riots that blighted the capital in August 2011.

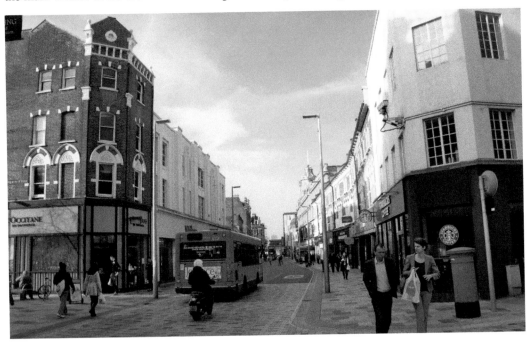

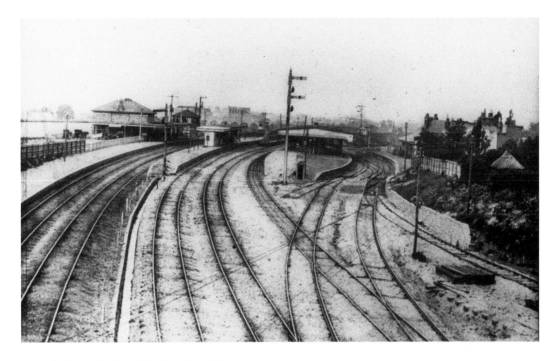

Railway Tracks, Clapham Junction

This photograph, taken less than ten years after Clapham Junction opened in 1863 and showing the tracks belonging to the London & South West Railway on the left and London Brighton & South Coast Railway on the right, illustrates the importance of the railway station to the subsequent development of the area. Until then, each railway company had its own stations. Now, for the first time, passengers could transfer easily from one service to another, opening up travel to and from London and other parts of the country. Today, Clapham Junction is Britain's busiest railway station, with over 2,000 trains passing through every day.

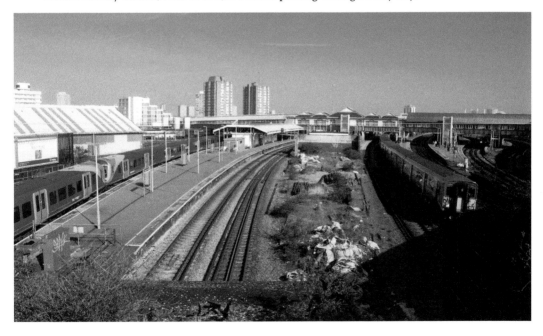

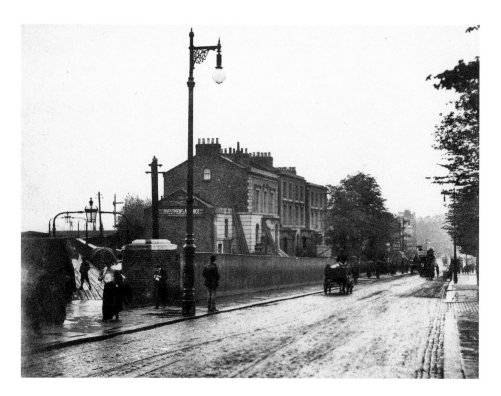

Clapham Junction (Upper Entrance)

The upper level entrance before it was enlarged by the London Brighton & South Coast Railway in 1910. Further down the road, a horse-tram makes slow progress up St John's Hill. In spite of repeated attempts to have Clapham Junction renamed as Battersea station, the misnomer persists. In fact, to add insult to injury, the centre of Battersea is now referred to by the same name – a predicament that continues to perplex unsuspecting visitors 150 years later, who discover on arrival that they are actually more than a mile from Clapham.

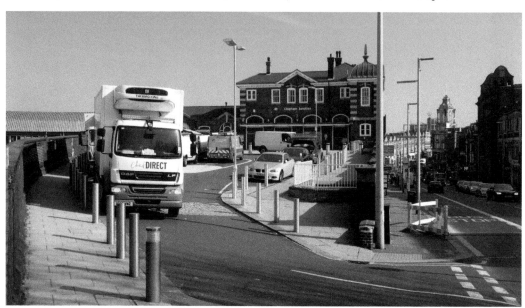

The Grand, St John's Hill

This photograph shows that until recently there were not one but two Grands on St John's Hill. The original Grand, in the back of Munt's piano shop in the centre, opened in 1894. It was always too small and respectable to meet demand, however, and it saw its last performance in October 1900, just one month before its new neighbour opened. After spells as a cinema and bingo hall, it was demolished in the early 1980s. For half a century, the New Grand staged variety and other live performances, until 1950 when it was sold to Essoldo and converted into a cinema. It then became a bingo hall, before falling into disuse during the 1980s. It narrowly avoided sharing its predecessor's fate and is now a nightclub and live music venue.

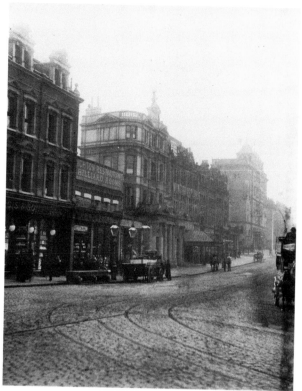

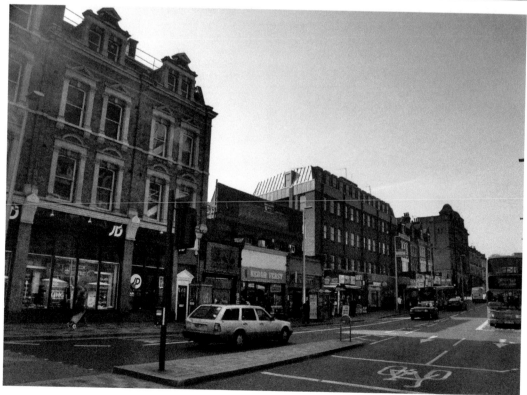

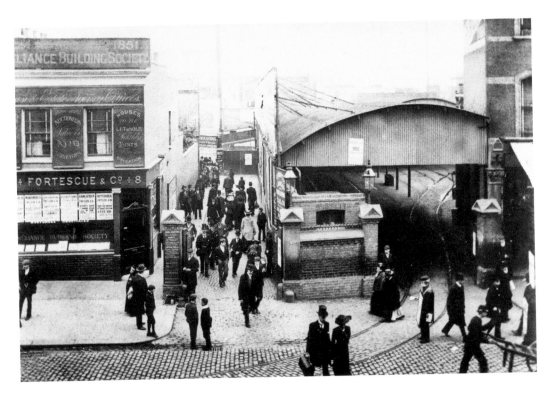

Clapham Junction (Lower Entrance)

For a century, the main entrance to Clapham Junction station was little more than an outdoor shopping alley, through which thousands of passengers passed every day. On the right, the tracks lead out of the old tram depot. After several remodels, today's commuters jostle past the flower stall into a bright, modern concourse lined with several leading high street chains.

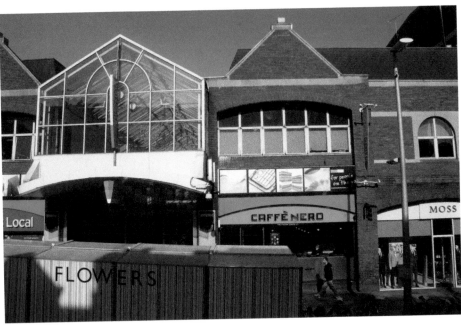

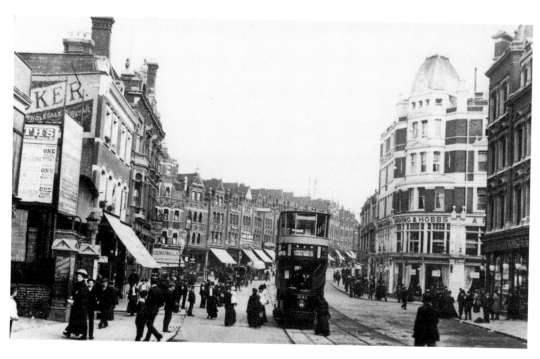

Arding & Hobbs

From a small shop in Wandsworth High Street, Arding & Hobbs rapidly expanded their drapery and furnishings business, opening the department store on the corner of St John's Road and Lavender Hill, here on the right in 1885. Battersea's only department store, it became known as 'the Harrods of the South'. It was totally destroyed by fire on 20 December 1909 with the loss of eight lives. The store was rebuilt and reopened a year later. Ever since the company went into administration in 2005, the building has been occupied by Debenhams, but the store is still widely referred to by the names of its original founders.

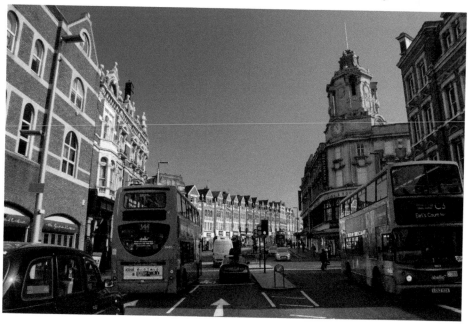

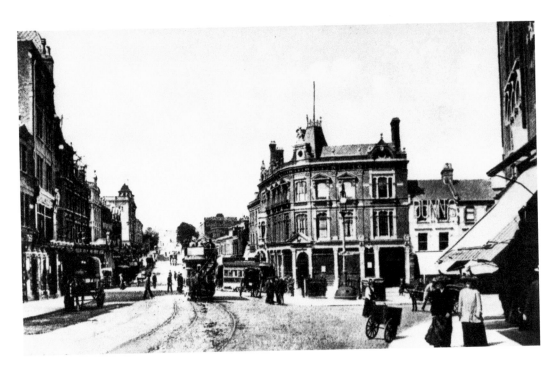

The Falcon, St John's Hill, Battersea, 1863
This old inn goes back to at least the early eighteenth century and catered mainly for passing travellers. The present building dates from 1882 and, according to the Guinness Book of Records, houses the longest continuous bar counter in the country. The centerpiece, however, is a stunning stained glass window depicting a falcon, part of the crest of the St John family, from which the pub derives its name. The party shop in the foreground on the right was burnt down in the riots in the summer of 2011, but has since reopened and expanded.

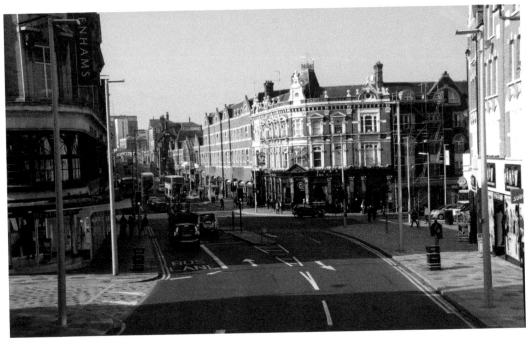

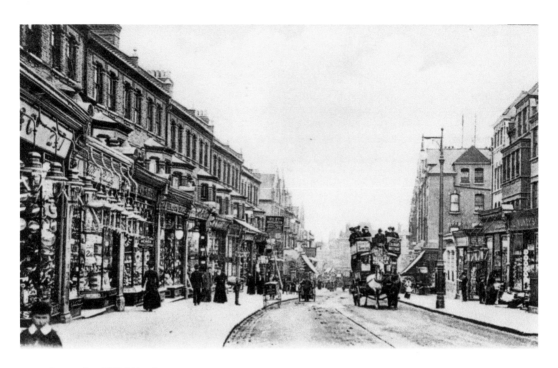

Lavender Hill (West)

Thanks to the gravels, loams and sands that form much of its soil, by 1800 Battersea was renowned for both asparagus and lavender. After William Pamplin set up his nursery business to cultivate herbs and lavender for the perfume industry on either side of the road to London, it quickly became known as Lavender Hill. Prior to the construction of the parade of shops on the left in 1889, the Chestnuts estate stood there on former farmland. Parts of the farmhouse, dating from 1812, survive on the other side of the buildings in Mossbury Road.

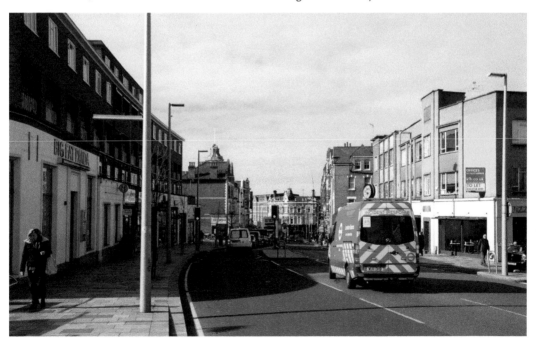

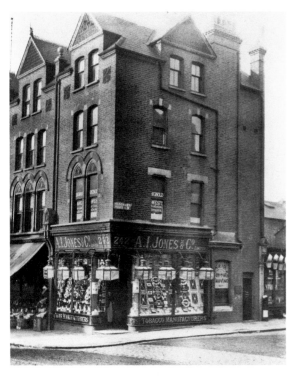

**Jones Tobacconist,
No. 242 Lavender Hill**
The crescent of buildings at the bottom of Lavender Hill to the north (*opposite page*) are among the few remaining buildings from the late nineteenth century, and No. 242 Lavender Hill, at the junction with Mossbury Road, is clearly recognisable in the previous photograph. This was the site of Jones Tobacconist, whose shop windows were as impressive as the gas lanterns that hung in front. Note the barber's shop to the rear and the offices of Bignold & West, architects and surveyors, above.

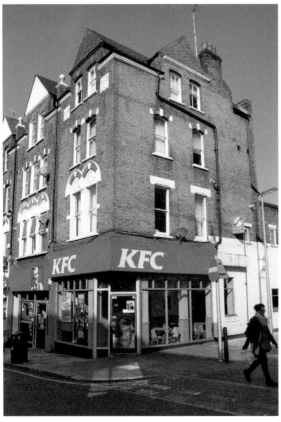

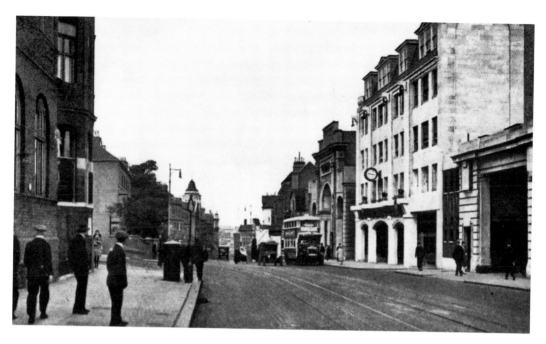

Civic Buildings, Lavender Hill

As well as shops, the crest of Lavender Hill emerged as Battersea's civic centre. On the left stands Battersea Central Library, opened in 1889. On the far right is the central post office, which was rebuilt in 1961 to replace the original from 1898. Next to it stood Electric House, the Battersea Borough Council electricity showrooms, where many local housewives were trained to use such newfangled electrical appliances as kettles and irons, and beyond that the Pavilion Theatre, a casualty of a V1 flying bomb on 17 August 1944. The combined sites have been occupied by supermarkets since 1985.

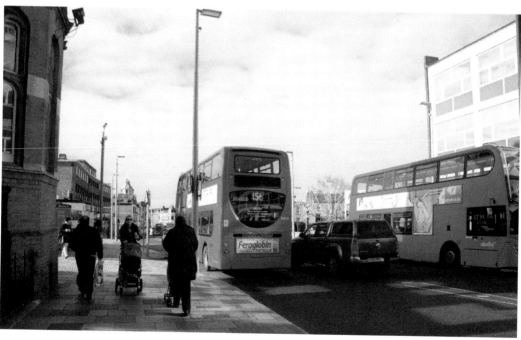

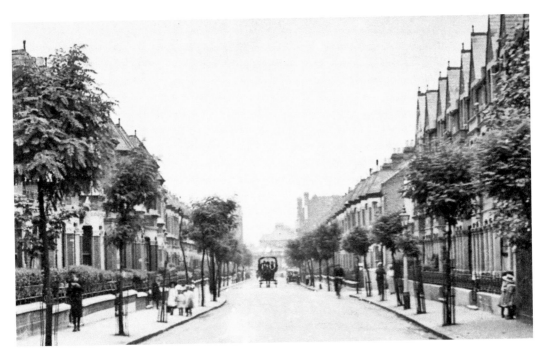

Elspeth Road

Further along Lavender Hill stand two more civic buildings, Wandsworth Magistrates Court and the Lavender Hill police station, and on the opposite side of the crossroads with Latchmere and Elspeth Roads, a former council office block – all architecturally as criminal as the Lavender Hill Mob in the eponymous 1951 Ealing comedy. Running north from Clapham Common, Elspeth Road was once another quiet avenue, but after a V1 flying bomb struck the junction with Lavender Hill, council flats were built on the right side and the vacant plots on the left were eventually put to use in the 1960s to widen the crossroads, transforming the road into a major thoroughfare.

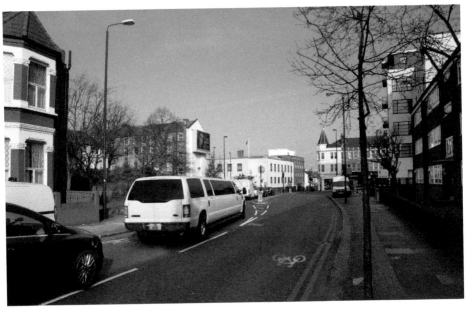

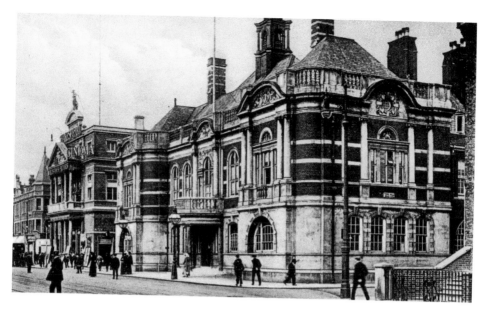

Battersea Old Town Hall & Shakespeare Theatre

The Town Hall was opened by Lord Rosebery, a future Prime Minister, in 1893. As well as for local government, it was used for concerts, exhibitions, political rallies, boxing matches, ballroom dancing and other cultural activities. It became redundant following Battersea's amalgamation with Wandsworth in 1965, but it reopened in 1981 as the Battersea Arts Centre, which has since built a reputation for experimental theatre. The Shakespeare Theatre opened in 1896 and witnessed the talents of such legendary names as Lillie Langtry and Sarah Bernhardt, before it was converted to a cinema in 1923. It was bombed during the Second World War and demolished in 1957. Now occupied by an estate agent, it is once again the setting for minor domestic dramas.

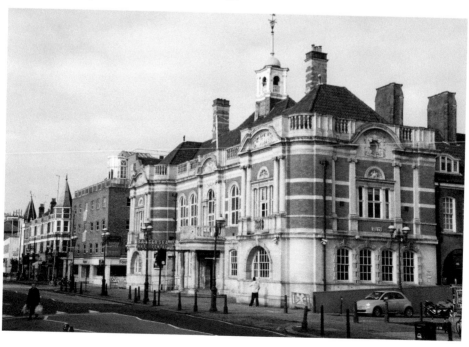

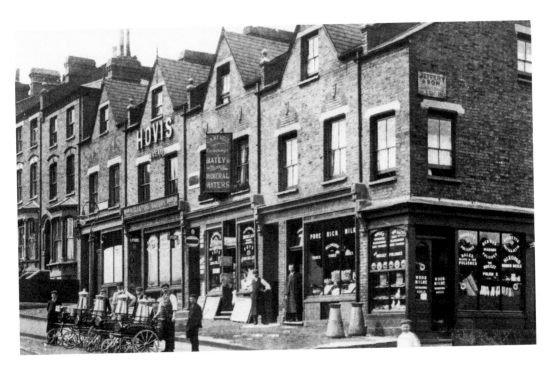

Bradbury's Dairy, Grayshott Road

Handcarts laden with milk urns line up outside James Bradbury's dairy, ready to start that morning's deliveries. The road is named after the village in Hampshire near the country estate of Edward L'Anson, the local district surveyor who developed this area in the 1870s. This (southern) end of Grayshott was rebuilt with public housing as part of the Gideon Road estate in the early 1970s and renamed Acanthus Road, originally further east along Lavender Hill, which was lost entirely during the same development.

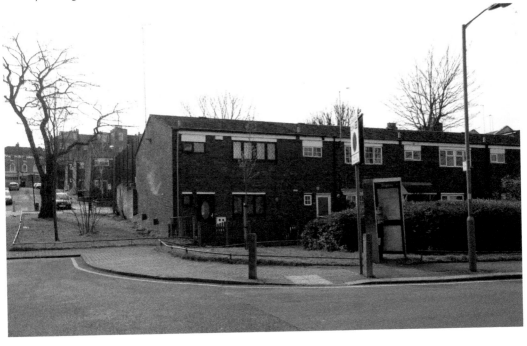

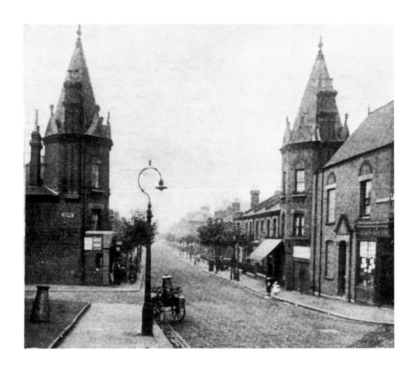

Shaftesbury Park Estate

These two 'tower' or 'turret' houses demarcate the southern entrance to the Shaftesbury Park estate. Uniquely, this estate was developed not by the usual landowners or the Conservative Land Society, but by the working men of the Artisans, Labourers & General Dwellings Company. A large scheme of 1,000 homes, intended to be free of taverns and pubs, the first stone was laid in 1872 by the great Victorian reformer, the Earl of Shaftesbury.

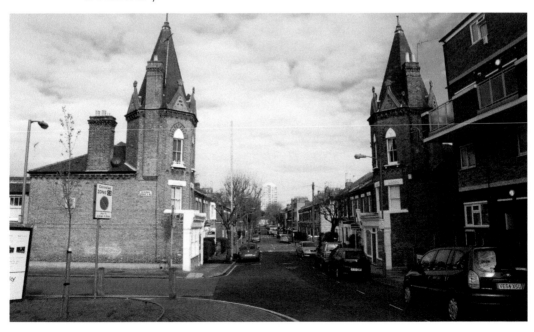

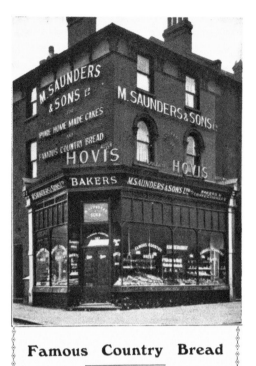

Famous Country Bread
───────────
137 LAVENDER HILL, S.W.11
and at—
37 BALHAM HILL - S.W.12
90a ST. JOHN'S HILL, S.W.11

Saunders Baker's, No. 137 Lavender Hill
Standing on the corner of Sugden Road and
Lavender Hill, opposite the church of the
Ascension, Saunders baker's provided the local
community with their daily bread. Saunders
owned two other baker's shops in the area, one
on St John's Hill and the other further south
in Balham, and were famous in particular for
their country bread. The estate agents that
occupy the premises today are less farmhouse,
more townhouse.

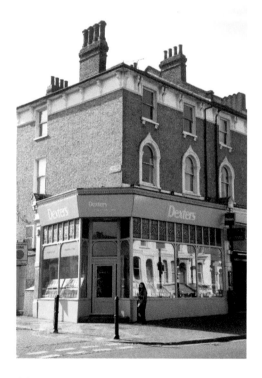

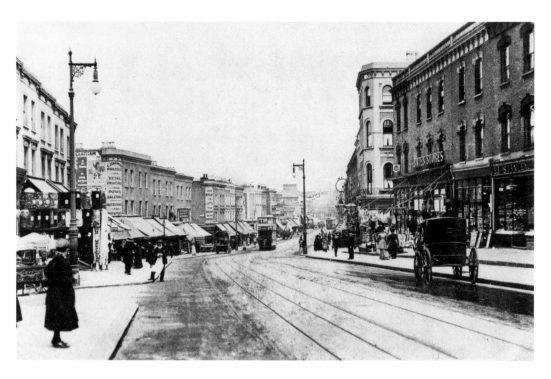

Lavender Hill (East)

A view down the eastern brow of Lavender Hill. Another baker, Hemmings, occupied the shop on the left-hand corner with Queenstown Road and suffered damage on more than one occasion from runaway trams failing to make the left-hand turn at the bottom of Cedars Road coming in from the right.

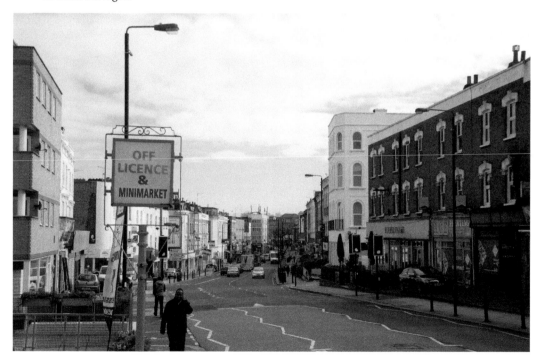

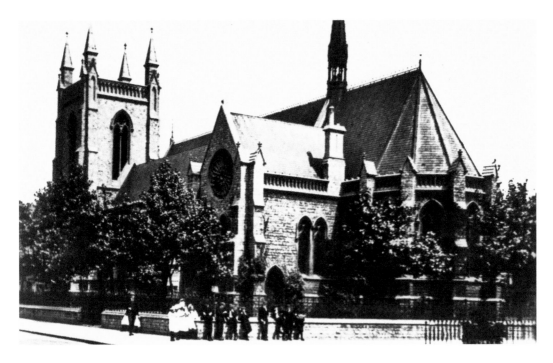

St Philip's Church, Queenstown Road

The church opened in 1870 on land donated by the local landowner and developer, Philip W. Flower, to enhance his Park Town development. It was Battersea's only estate church and Flower's sponsorship may also account for the choice of saint. It was designed by James Knowles, the last of four designed by him in south London, and built at a cost of £13,000. The church formally closed in 2006 and is currently occupied by the Ethiopian Orthodox Tewahido church. It was the scene of a small, but violent, demonstration between rival Ethiopian factions in October 2013.

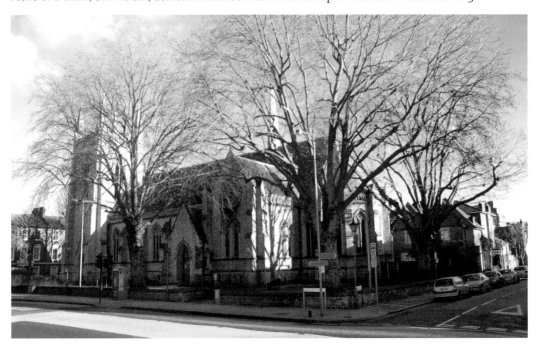

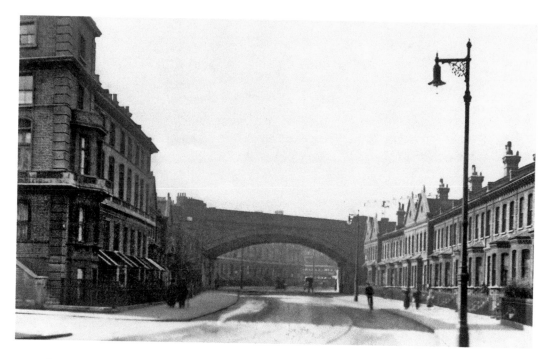

Queenstown Road (North)

Originally Queen's Road, a logical as well as a physical extension of Victoria Road, which ran southwards from Victoria (later Chelsea) Bridge to Battersea Park Road. The entire length was renamed Queenstown Road (a composite of the original road name and the Park Town estate through which it ran) in 1937, although the railway station at its midpoint was not renamed until the 1990s. The photograph below shows where the road was lowered under the bridge in 1927 to allow double-decker trams to pass underneath.

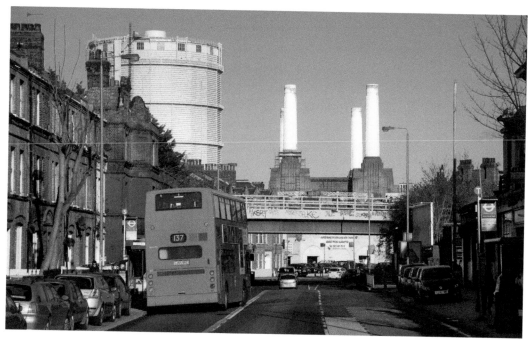

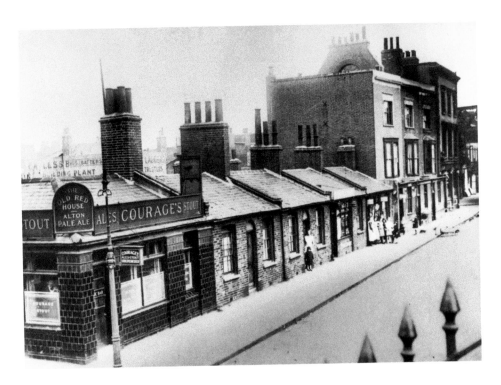

Stewart's Lane (Now Road)

A view of the single-storey terrace, including the Old Red House and Pavilion Tavern, shortly before demolition in 1934. Named after the Stewart family, who developed the area at the start of the nineteenth century, it was part of a scheme for a Battersea New Town. However, the area became so hemmed in by the emerging railway system that it soon acquired an unhealthy reputation and, in 1933, it was designated for slum clearance. The process was accelerated during the Second World War when, again because of its proximity to the main railway network, it was the most badly damaged residential area in Battersea. The New Town was finally replaced in the 1950s, but the twenty-eight blocks of flats that make up today's Patmore Estate recall its railway origins by taking the names of locomotive engineers.

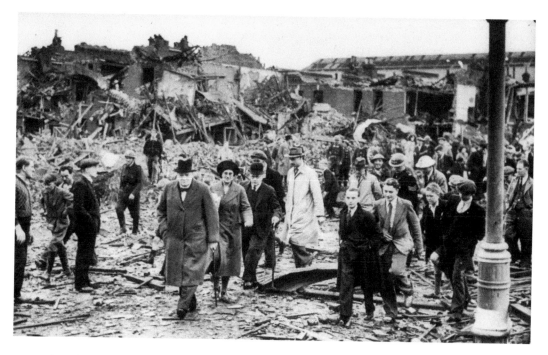

Nine Elms

Nine Elms was an early industrial area of Battersea featuring factories, riverside wharfs, malting kilns and several railway works. Inevitably, the area was a frequent target during the Blitz, and after one such attack in 1940 it was visited by the Prime Minister and wartime leader, (later Sir) Winston Churchill. In the post-war period, the traditional industries gradually declined until they were replaced in 1974 by the fruit and vegetable wholesalers of the New Covent Garden. Today, construction work is underway on a new garden, Embassy Gardens, a 15-acre residential and business development that will see 2,000 new homes, a hotel and as many as twelve embassies located there by 2020.

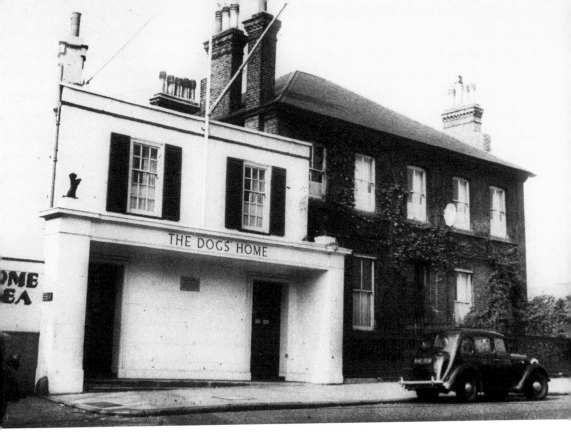

Battersea Dogs & Cats Home

The home, founded in 1860 at Holloway by Mrs Tealby and Mr Major, moved to Battersea in 1871. Cats were first admitted in 1882, but it was not until 2002 that it changed its name to reflect this. Since its foundation the animal rescue organisation has cared for over 3 million animals.

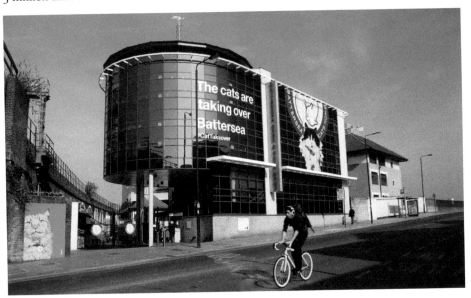

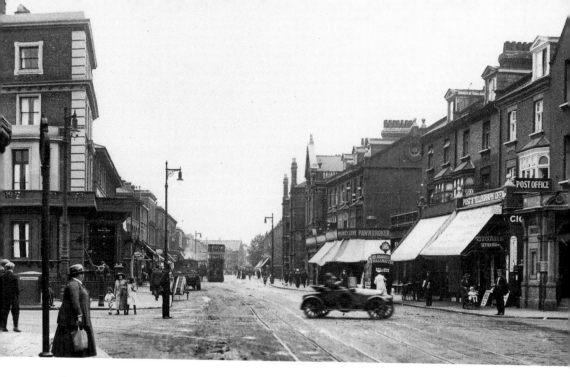

Battersea Park Road with Queenstown Road

The scrolled pediment and angled porch of the bank on the right on the corner with Queenstown Road remain, and the post office next door continues to this day. The south side of the street has completely vanished, however, replaced by the Newtown Development and Rollo and Doddington estates, Battersea's largest collection of post-war public housing estates.

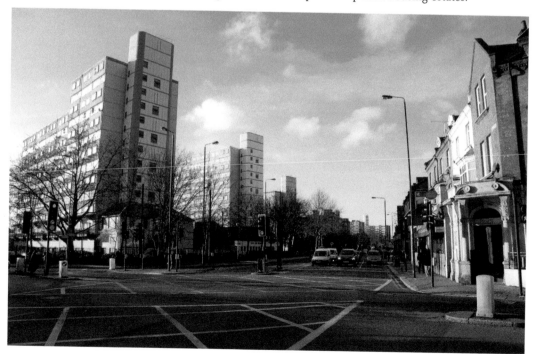

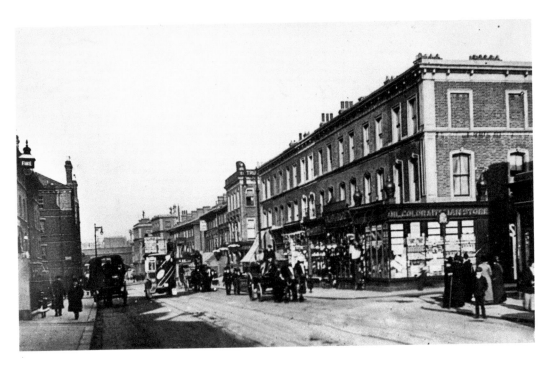

Battersea Park Road (East)

Horse-drawn vehicles pass in front of a parade of shops, the nearest of which is adorned with urns of oil. The Doddington estate that has adorned the site since 1970 was an expensive experiment in industrialised building. From the outset it was plagued with problems, dogged by allegations of corruption and terrorised by criminals. A combination of privatisation and recladding has lifted the area and it might yet become what Wandsworth Council once hoped would be a place 'a middle-class couple can come back to late at night and buy some pâté and a bottle of wine.'

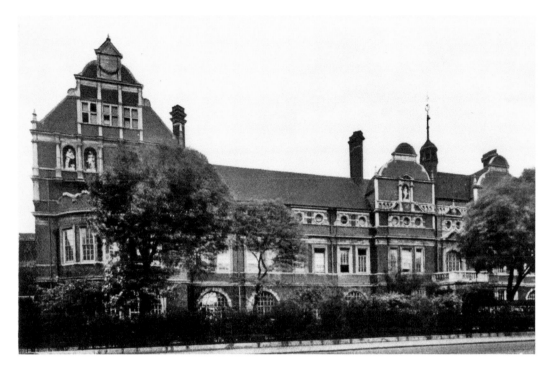

Battersea Polytechnic Institute

Founded in 1891 to provide greater access to further and higher education for some of the 'poorer inhabitants' of London, the polytechnic admitted its first students three years later. In 1956, the Institute was among the first designated Colleges of Advanced Technology and renamed the Battersea College of Technology. Just ten years later, it was accorded even higher status as the University of Surrey, but in a matter of a few years it had relocated to its present site in Guildford. In 2006–08, the vacant buildings were finally converted to housing and renamed Kingsway Square.

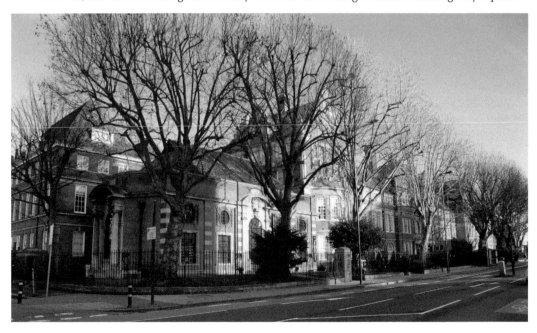

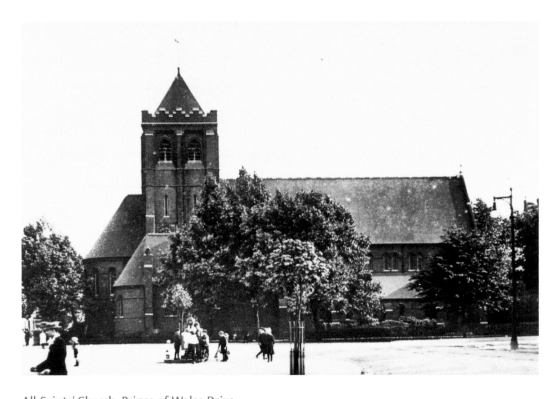

All Saints' Church, Prince of Wales Drive

The original church, consecrated in 1883, was damaged by fire in 1969 and demolished soon after. It was replaced in 1978 by a very different type of building, with a copper-clad pitched roof over the church proper and single-storey wings with flat roofs to the east and west – a striking contrast to the elegant, five-storey mansion blocks that line the length of the rest of the road.

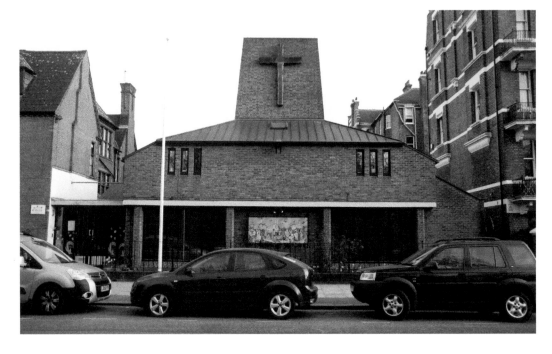

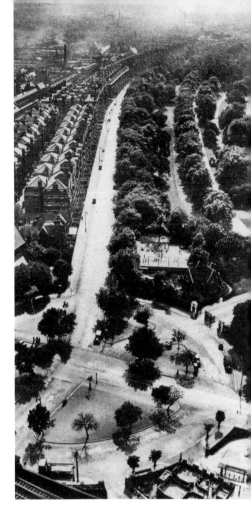

Queen's Circus & Prince of Wales Drive

The earlier crossroads was converted into the present grass-covered roundabout at the time of the Festival of Britain in 1951. The Drive owes both its name and its location to the Albert Palace, a glass and iron structure similar in design to the Crystal Palace that was built for the Dublin Exhibition in 1865. Afterwards, the Palace was reconstructed on the south side of the new Battersea Park and reopened in 1885. It did not prove a commercial success, however, and closed after just three years. The Palace was then demolished in 1893 and replaced with today's mansions.

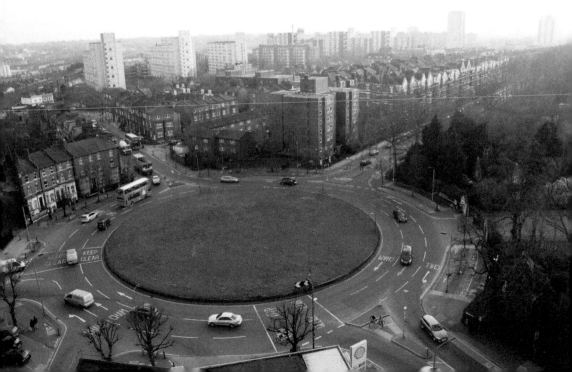

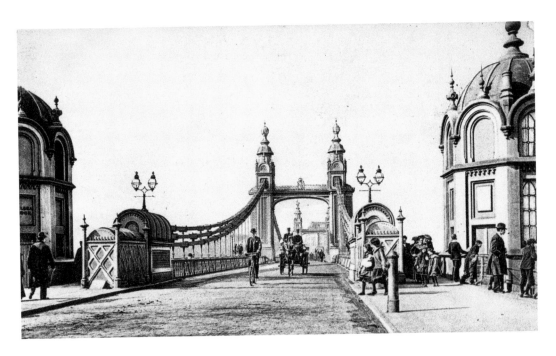

Chelsea Bridge

The first bridge was completed in 1858 to enable the residents of Chelsea to access the new park. Originally called Victoria Bridge after the monarch who opened it, the bridge was renamed after it was found to be structurally unsound to avoid risk to Her Majesty's reputation. The octagonal stone houses at either end of the bridge were used to collect tolls, but these were unpopular and cancelled in 1879. It was replaced in 1937 with the structure we see today, the first self-anchored suspension bridge in Britain.

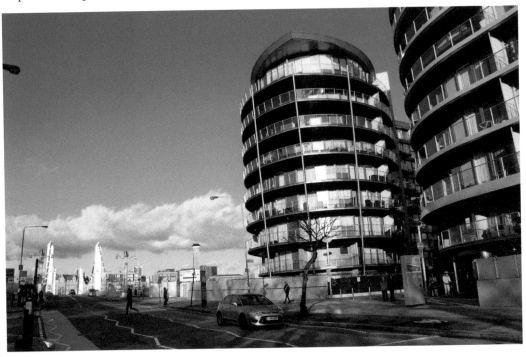

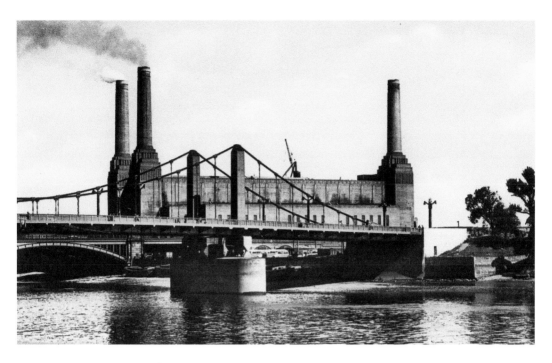

Battersea Power Station

Construction work on Battersea's most iconic building was completed in 1935. Initially, the power station consisted of one turbine hall with a chimney at each end. A second turbine hall was added in 1955 to give the building – and Battersea – its distinctive skyline. In spite of being a listed building, its survival has been uncertain since its closure in 1983, passing from one developer to another. Finally, in 2012 the power station was sold to a Malaysian-led consortium for conversion into residential apartments known as 'Circus West'. The new building in front of it is Chelsea Bridge Wharf.

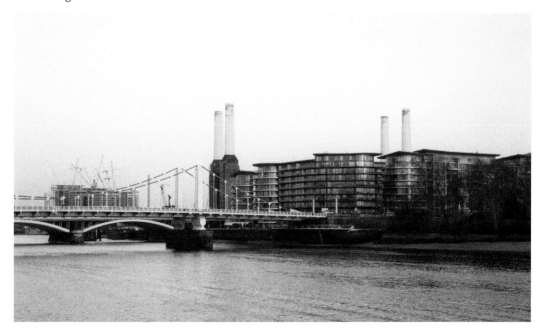

The Thames at Chelsea Bridge

During excavations for the original bridge, workmen found many Roman and Celtic weapons on the riverbed, the most significant of which was the bronze and enamel Battersea Shield. These and similar finds at Albert and Battersea Bridge have led some historians to believe that Julius Caesar forded the Thames here during his invasion of Britain in 54 BC.

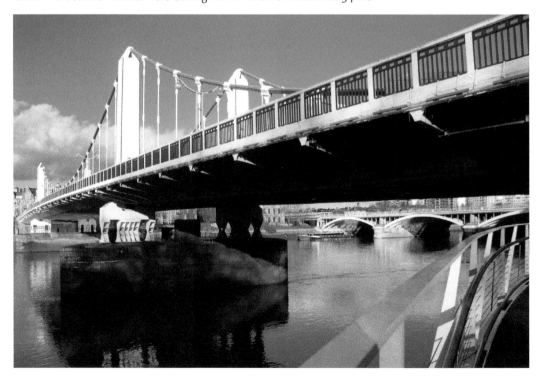

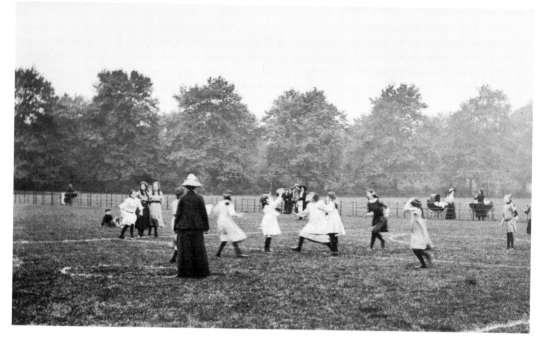

Playing Fields, Battersea Park

On the same day in March 1858 that she first crossed the bridge from Chelsea, Queen Victoria also opened Battersea Park. The park comprises 200 acres – almost one-tenth of the entire borough – and was created by reclaiming the marshy riverside area of Battersea Fields, the venue for the 1829 duel between the then Prime Minister, the Duke of Wellington and the Earl of Winchilsea. The 'People's Park' was the setting for the world's first official game of Association football on 9 January 1864 and remains a popular recreation facility today.

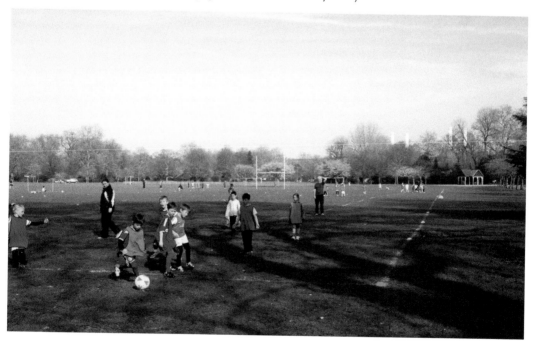

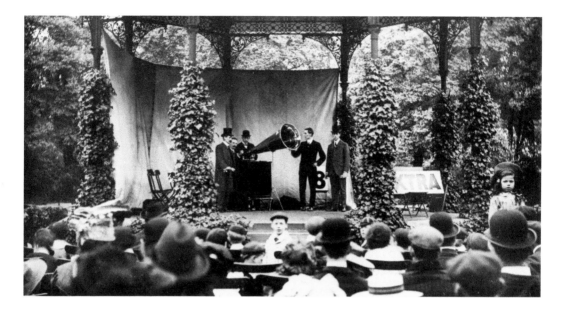

Bandstand/Peace Pagoda, Battersea Park

The original bandstand, with its ornate wrought-ironwork, was a popular destination for visitors and, in 1900, the area around it had to be enlarged to permit seating for 1,000 people. A revolutionary new technology employing compressed air amplification, developed by HMV and incorporated in its Auxeto gramophones, was so effective that 'gramophone concerts' attracted audiences of thousands here and to other public parks, providing the working classes with more enlightened recreation. Today's technology enables visitors to listen to their own choice of music through tiny earphones, while others can contemplate in silence the London Peace Pagoda that was erected on the riverside walk by the monks, nuns and disciples of Nipponzan Myohoji to celebrate the 1984 GLC Peace Year.

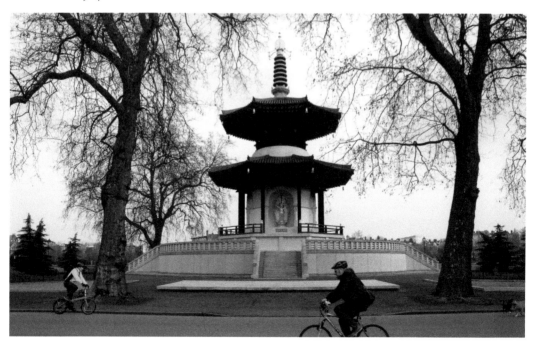

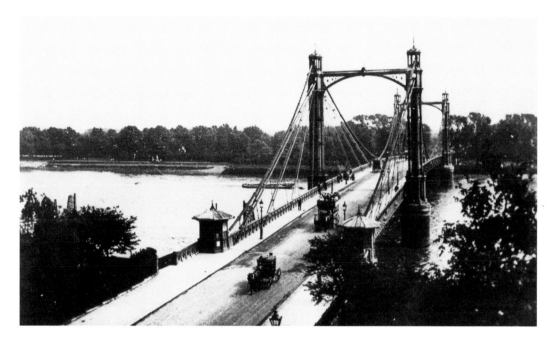

Albert Bridge

Albert Bridge is one of the few suspension bridges over the Thames in London. It is also one of its most attractive, especially at night when it is illuminated. It was built privately between 1871 and 1873, and today's bridge is the original although it has since been modified and strengthened to cope with the much greater volumes of traffic it carries today. The modern-day sign nevertheless reinforces the earlier warning, visible on the tollhouses on either side, that 'all troops must break step when marching over this bridge'.

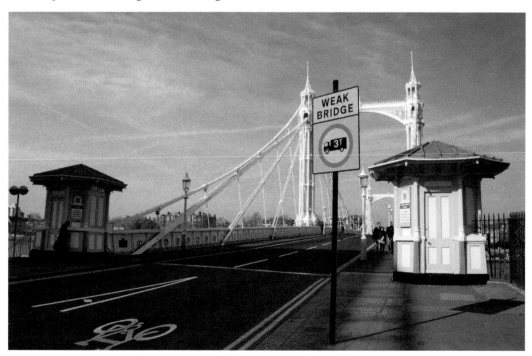

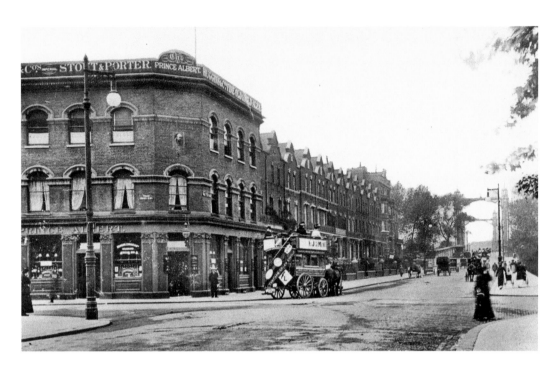

The Prince Albert, Albert Bridge Road

Albert Bridge at the top of the photograph was first proposed by Prince Albert in 1860. The road itself, which runs along Battersea Park's western edge, follows an earlier track and was first called Prince Albert Road. The pub that stands on the corner dates from the late 1860s and is the oldest building on the road. It understandably bears the Prince Consort's name, as does the latest addition to the road, the apartment block at the far end of the terrace, beside the bridge.

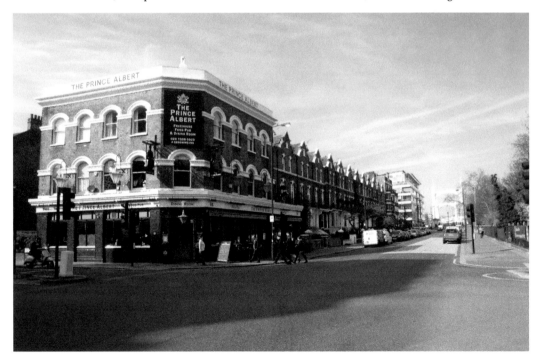

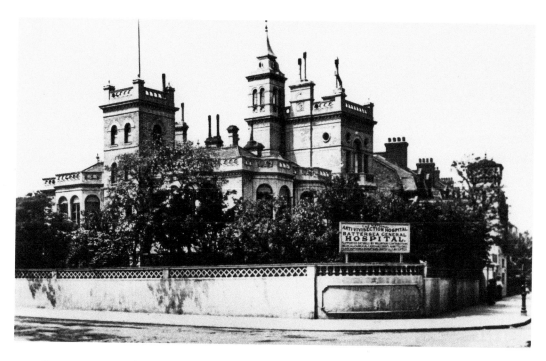

Battersea General & Anti-Vivisection Hospital

Situated at the southern end of Albert Bridge Road at the corner with Prince of Wales Drive, the hospital was founded in 1902 for the treatment of humans, but was so named because it refused to experiment on animals. Consequently, a statue of a brown dog was erected nearby four years later, a gift from the Anti-Vivisection Council. The statue became the focus of attacks by medical students from University College and it had to be guarded by police until the decision was taken to demolish it in 1911. The hospital was damaged by bombs during the war but remained open until 1971, when it too was soon demolished.

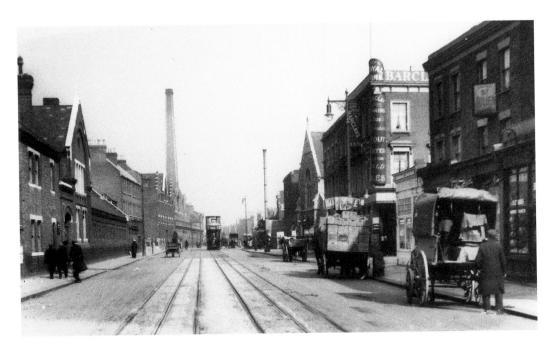

Battersea Park Road (Middle)

In the early nineteenth century, the road was no more than a country lane across the open Battersea Fields and Longhedge Farm. After Battersea Park was opened, the estates were laid out to the south, followed in the 1880s by the mansions along Prince of Wales Drive. Shops and light industry grew up along the road to meet the needs of the burgeoning local population and provide employment. The 70-foot chimney on the left served the steam laundry belonging to the caterers Spiers and Pond, erected in 1879 on the corner with Alexandra Avenue, which employed hundreds of local women. It was demolished in 2006 and replaced two years later with a residential building, the Quadrangle.

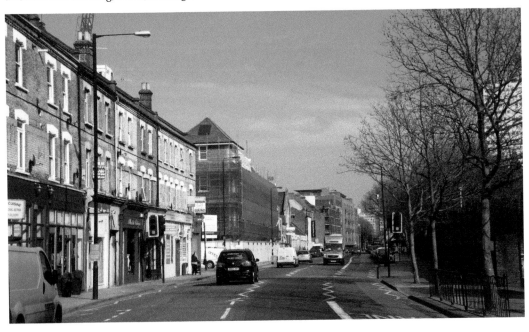

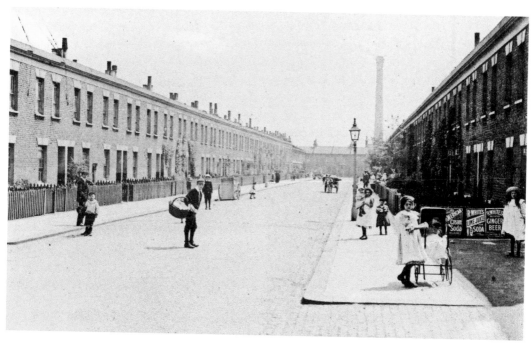

Parkside Street

Children, presumably in their 'Sunday Best', play happily in the street. Note the almost complete absence of road vehicles, unlike today's scene. Built in the 1860s, only this northernmost tip of the original street, at the junction with Battersea Park Road, exists today. The rest of it and neighbouring Chesney Street to the west are today the site of Chesteron Primary School.

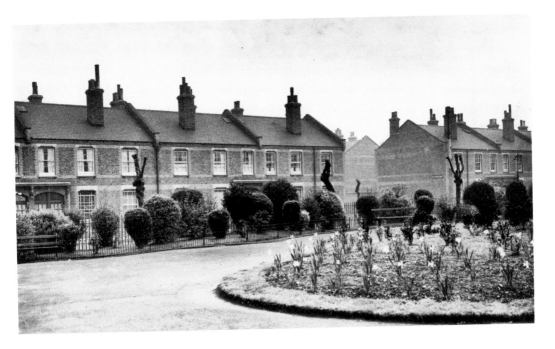

Reform Street, Latchmere Gardens

As part of the Latchmere Conservation Area set up in 1978, the houses built in Latchmere Recreation Ground at the turn of the twentieth century have survived largely unscathed from the changes that have sprung up all around them, such as Challis House in the background. The street name was a rather prosaic compromise between the radical and other members of Battersea Council – unlike Joubert Street on the opposite side of the Recreation Ground, which is named after the Boer General who inflicted a notable defeat on the British forces during the (Second) Boer War only a few years earlier – Battersea being at the centre of the campaign to 'Stop the War'.

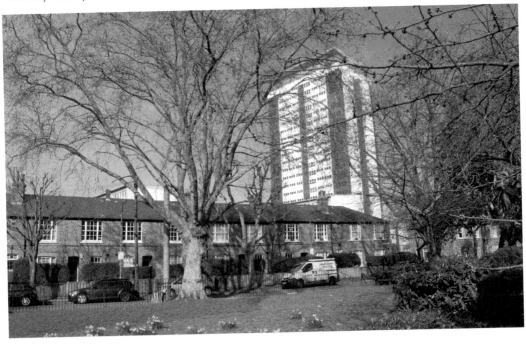

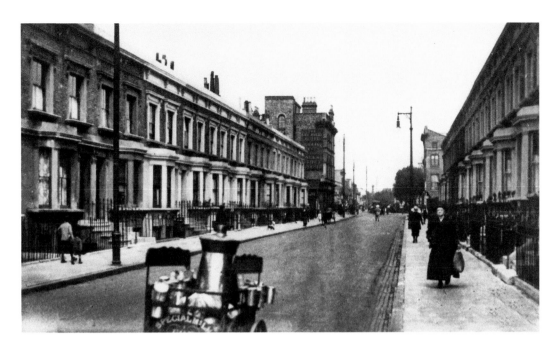

Milk Cart, Latchmere Road

The name of the road derives from Old English and reflects the wet and boggy nature of the land before development. Perhaps not entirely coincidentally, the Latchmere Public Baths were formerly sited nearby, since replaced by the Nuffield Health, Fitness and Wellbeing Centre. The houses on the right were lost during the Second World War, now the home of the Harling Court housing development. On the far left corner with Battersea Park Road stands the Latchmere public house, one of three that remain of the original twelve in the area, and the venue for Theatre 503 (formerly the Grace Theatre), renowned for its cabaret.

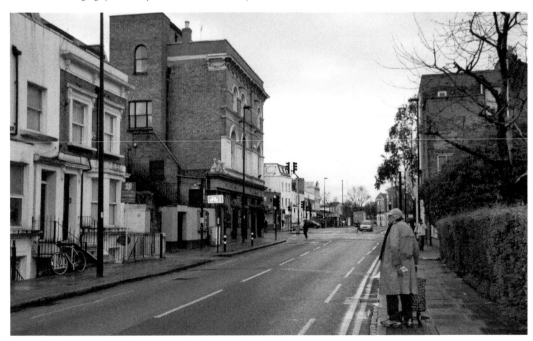

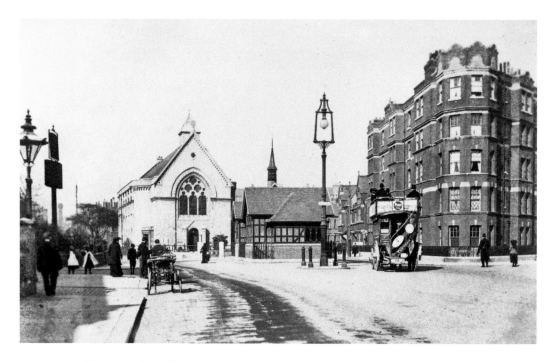

Battersea Bridge Road (South)

A horse and cart heads north along a murky Battersea Bridge Road towards the old Congregational church on the corner with Bridge Lane. On the same side, visible in the later photograph, stands the Duke of Cambridge public house, while the road coming in from the right is Cambridge Drive. Just out of view on the same side is St Stephen's church, which was declared redundant in 1976 and leased to the Assemblies of the First-Born in 1980, which eventually bought the building in 2007.

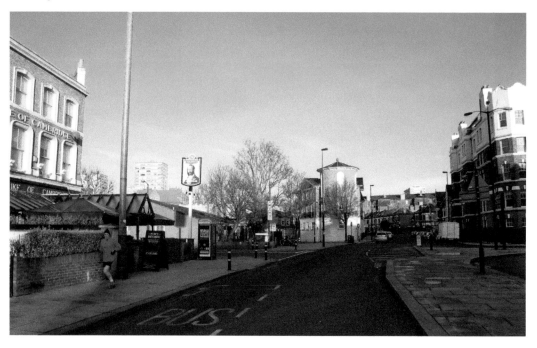

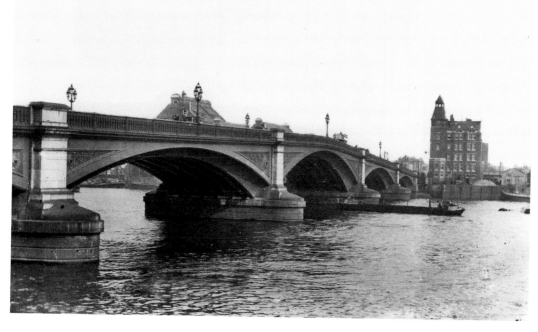

Battersea Bridge

The original bridge, erected in 1777, was the last surviving wooden bridge on the Thames in London until its demolition in 1885. Its successor was designed by Sir Joseph Bazalgette, chief engineer of Metropolitan Board of Works, who was responsible for building the capital's network of sewers. Not only is it London's narrowest road bridge over the Thames, its location on a sharp bend in the river makes it a hazard to shipping and the site of frequent collisions. The old riverside fire station that stood on the far right (west) end of the bridge has gone, offset by the glass and steel crescent of the Albion Riverside Building on the opposite side.

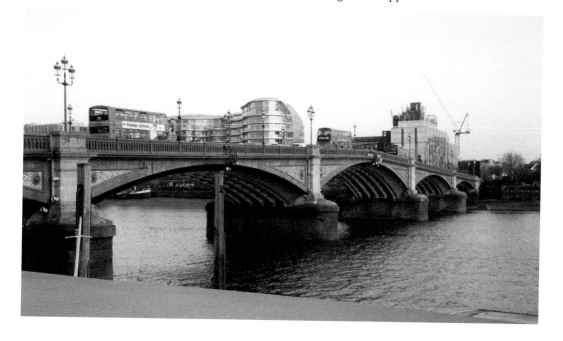

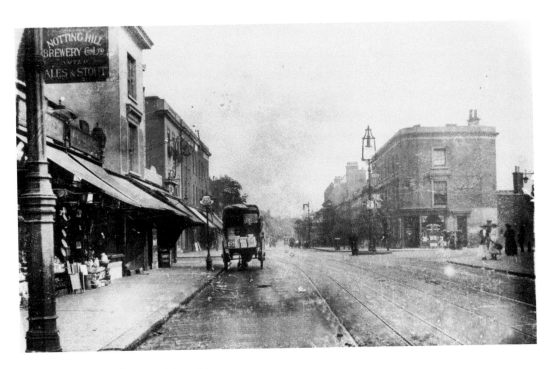

Battersea Bridge Road (North)

The early image is taken a little further down Battersea Bridge Road at the crossroads with Parkgate and Bridge Road West (now Westbridge), but the more interesting development since then has occurred at the top of the road. The old factory buildings on the west side of the bridge were steadily swallowed up by the Morgan Crucible, which lay behind. Battersea River Fire Station was the last to succumb in the early 1970s, shortly before the Crucible moved away from the area. Now the site forms part of the Thames Path. A recent addition on the left (east) is the Royal College of Art's Dyson Building.

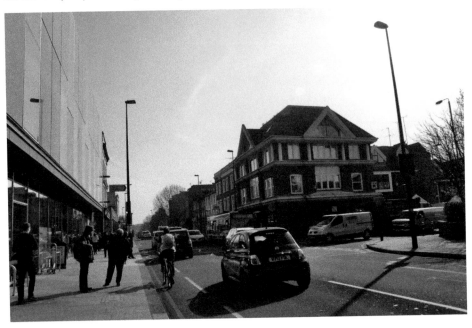

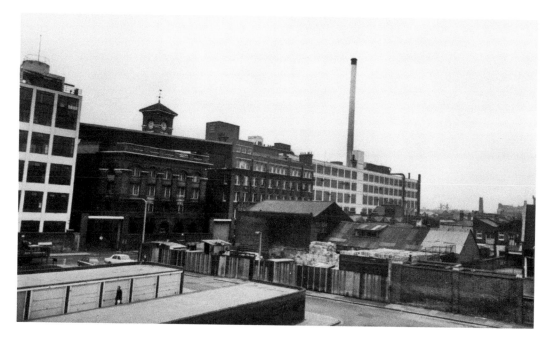

Morgan Crucible

Founded in 1856 as the Patent Plumbago Crucible Company by six (of the nine) Morgan brothers, within five years it was supplying crucibles to the Royal Mint and those in India, Australia, France, Germany and Russia, as well as to the Royal Arsenal at Woolwich. By the 1880s, and now renamed Morgan Crucible, the company had become the world's largest supplier of crucibles. It continued to thrive during the twentieth century and the need for more space eventually led to its relocation to South Wales in the mid-1970s. The factory was replaced in 1984 by Battersea's first big private housing development, Morgan's Walk, built on a remarkably modest scale in comparison to the industrial giant that previously stood there.

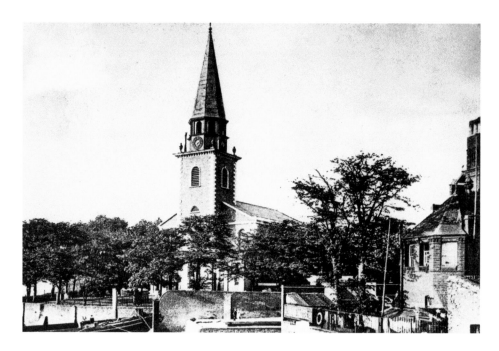

St Mary's Church

One of the earliest known consecrated sites on the south bank of the Thames, a church has probably stood here since AD 800. The present building was completed in 1777 and is the only Grade I listed church in Battersea. The artist and poet William Blake was married here, and J. M. W. Turner painted the river from the vestry window. Benedict Arnold, the American general who defected to the British during the American Revolutionary War, was buried here. The sign at the bottom of the photograph indicates that the building on the right was the Swan Hotel. The Rank Hovis McDougall flourmill behind, on the former site of Bolingbroke House, Battersea's manor house, was demolished in 1997 and replaced with the Montevetro apartment building in 2000.

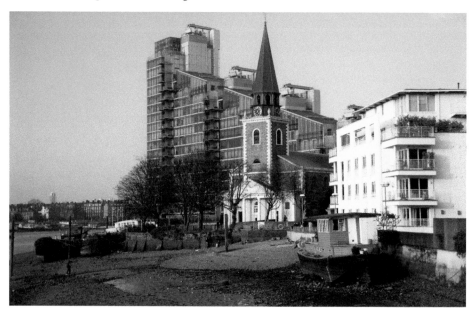

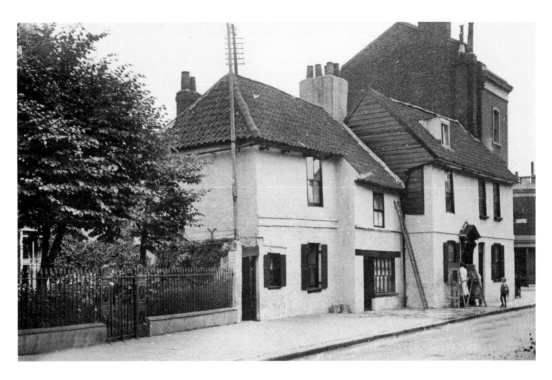

Old Battersea, Bridge Road West

This row of four houses, three of which were believed to date from the reign of Charles II (late seventeenth century) and the fourth a wood-panelled Queen Anne house from the early eighteenth century, was the last surviving trace of the old village of Battersea. They were pulled down in 1937.

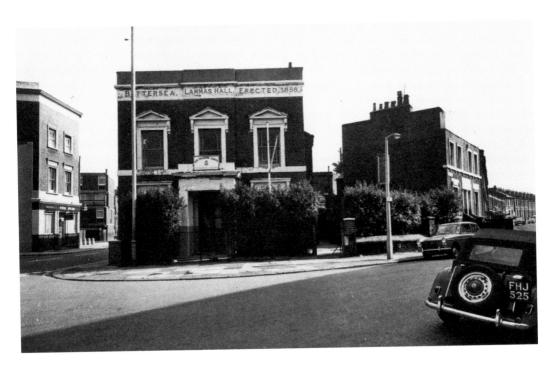

Lammas Hall & the Stag Tavern

Lammas Hall, Battersea's first public hall, was built in 1858/59 with money received from the Battersea Park Commissioners as compensation for the loss of farming rights (Lammas rights). From 1888 until 1926 it was a public library, before reverting to a public hall until the late 1970s, when it was demolished to make way for the Surrey Lane Estate. After several years as an Indian restaurant, the Stag Tavern on the left-hand side of the photographs reopened as a public house.

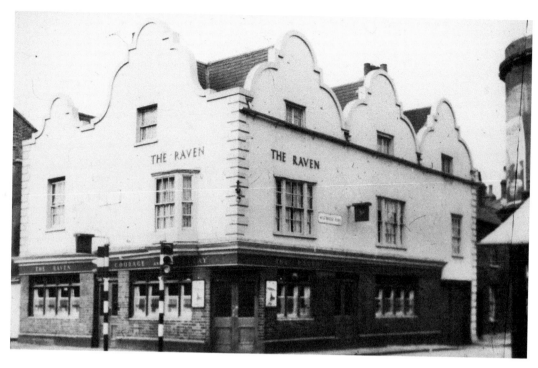

The Raven, Battersea Square

The Black Raven, as it was first known, dated back at least as far as 1701, and parts of the fabric of the building were even older. The sobriquet 'Black' may have been a reference to a sinister connection to smuggling, there being stories of a tunnel leading from the pub to St Mary's church uncovered during renovations in 1961. In any event, by the 1760s it was known simply as The Raven. Today, in keeping with the general gentrification of the area, it is a bar, trattoria and delicatessen.

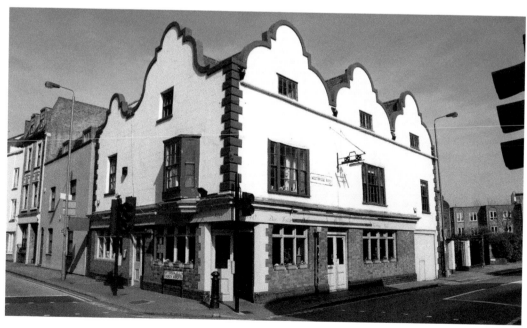

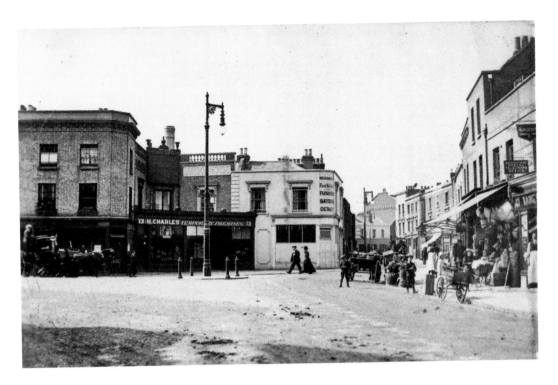

Battersea Square

Battersea Square, 'Old' Battersea's village green and, in actual fact, always triangular in shape, was the site of the village stocks and water pump. It was open road until pedestrianised in 1990, since when it has enjoyed an almost continental 'café culture', an impression heightened by the recent opening of the chef Gordon Ramsey's latest restaurant at London House, in the centre of these photographs.

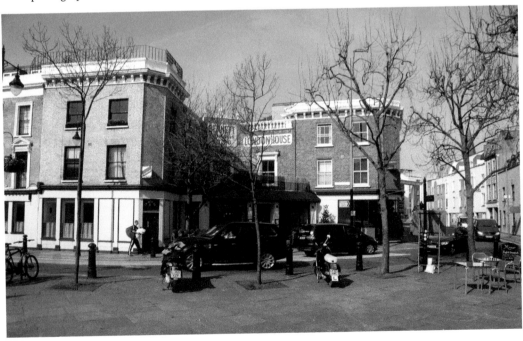

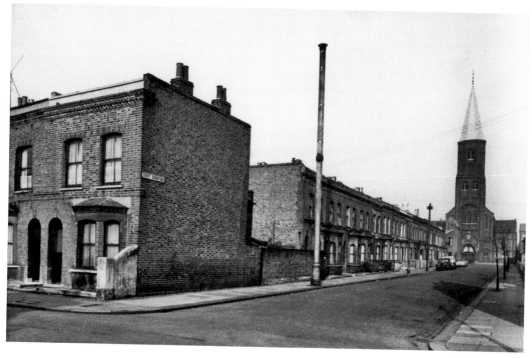

Church of the Sacred Heart, Trott Street

Named after the ironmonger and smith in Battersea Square, who bought the site in 1864. Shortly afterwards, he moved his business to Battersea High Street and in 1874 leased the northern end of the plot to allow the building of the church of the Sacred Heart, which he himself completed the following year after the original builder was sacked. This was replaced by the present church in 1893. Today, only this northern section remains, the southern half having been demolished in the 1960s for council housing.

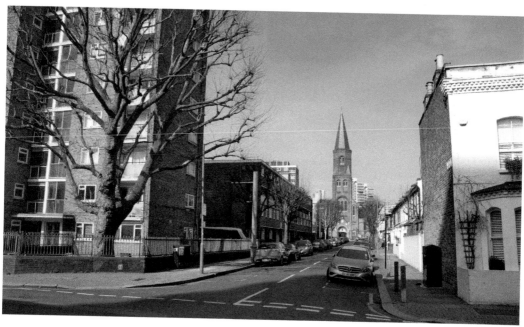

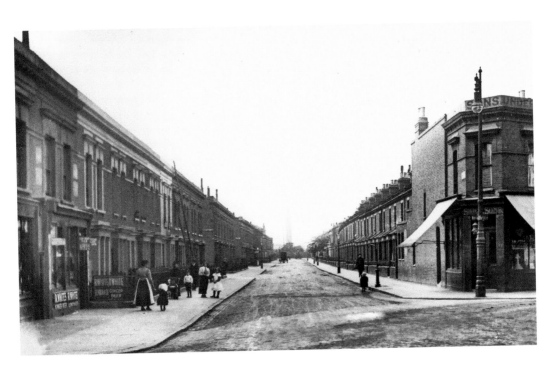

Gwynne Road

Little remains today of the small terraced houses built in the 1860s: the road was severely damaged by bombing during the war, with a V1 flying bomb delivering a final coup de grace in 1944. What little remained was condemned, then demolished, to make way for the York Road estate. Typical of the area, it is now a mix of high-rise flats and low-level industrial units. Oyster Wharf, a smart riverside apartment block, can be seen at the far end.

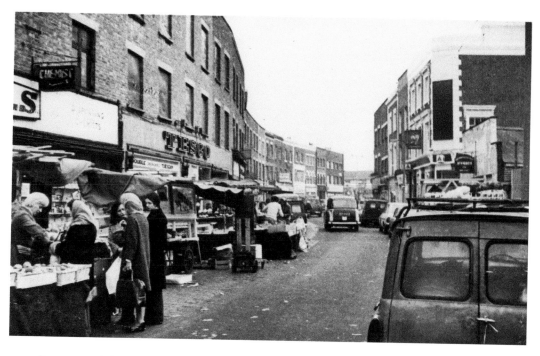

Battersea High Street

It is difficult to imagine that this narrow and, until recently, rather shabby alley was once the principal thoroughfare of the old Battersea village. It has seen some smart additions, most notably the Candlemaker bar and restaurant, but remains a distant echo of the main shopping centre further south around Clapham Junction. 'Battersea' railway station was a wooden structure attached to the bridge halfway between the Square and York Road. It was bombed in 1940 and was not reopened.

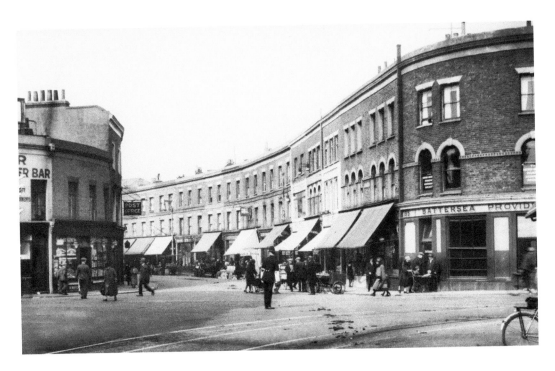

Battersea High Street/York Road

The southern entrance to Battersea High Street and a few shops to the west along the north side are all that can be seen today of an extensive parade of shops that ran westwards along both sides of York Road. They were cleared in the 1960s as far as Badric Road – now only a faint memory that lingers in the name of the large court to the west of the Methodist mission – and redeveloped under the York Road Stage 1 and 2 Schemes.

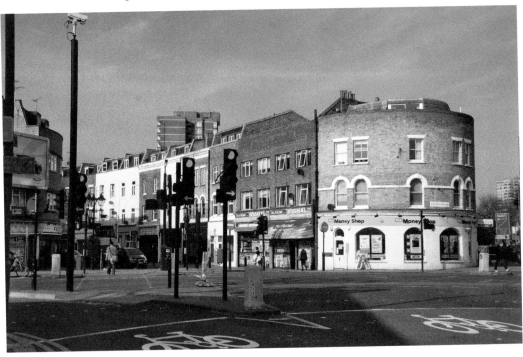

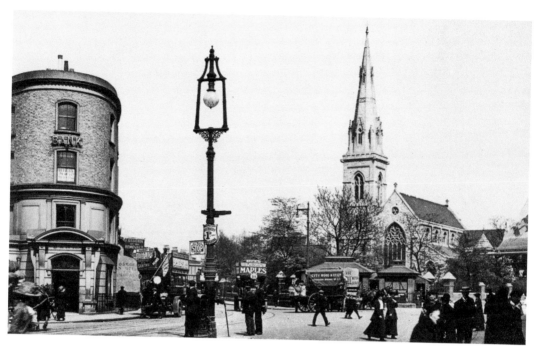

Christ Church, York Road

The original church shown here opened in 1849 and was the first offshoot of the parish church of St Mary's. It was destroyed on 21 November 1944 during the Second World War by the only V2 rocket to fall on Battersea, with the vicar's mother the only fatality. The low-level replacement that occupies the site today, the hemispheric roof of which can barely be seen behind the yellow commercial unit in the centre of the photograph, was built on the foundations of the first church and completed in 1959. The public gardens in front are dedicated to the memory of all Battersea's war dead.

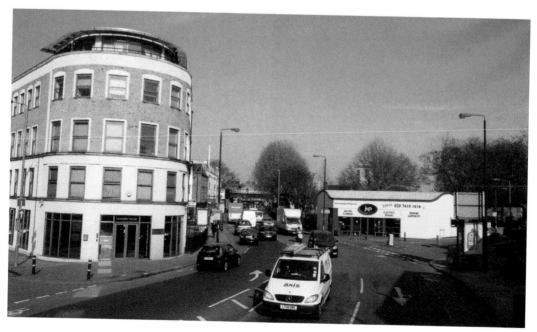

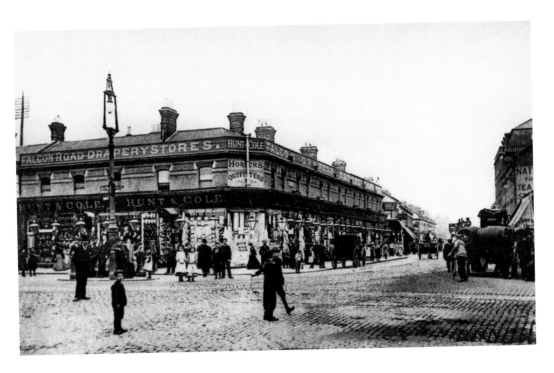

Falcon Road

This is the opposite end of the road to the Falcon Inn on the corner with St John's Hill in Clapham Junction, from which it takes its name. Prior to 1865 when it was culverted and covered by the District Board of Works, the Falcon Brook flowed from Balham, down the entire length of what are now Northcote, St John's and Falcon Roads, to the Thames. Asparagus, the name of the public house that currently occupies the dominant corner position, reflects the area's market garden origins.

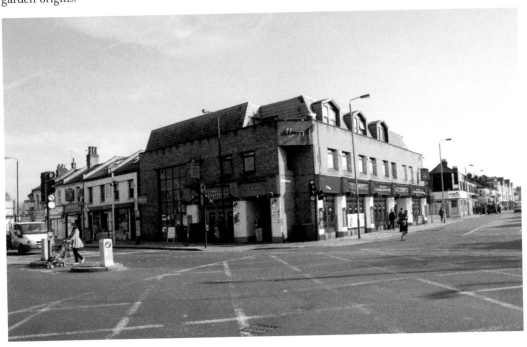

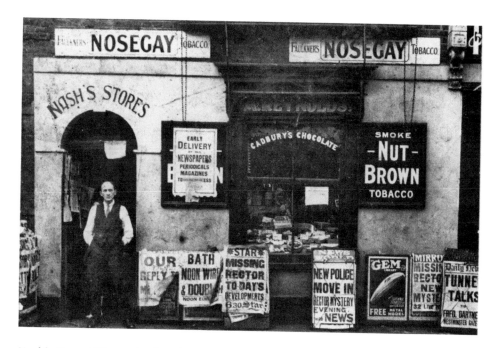

Nash's Store, Winstanley Road

The figure is not Nash, but A. Reynolds, who had just taken over the store by the time of this photograph around 1930. The original name of the store is still visible over the door, possibly in order to retain the previous owner's customers. Reynolds' own name has been added above the window. An even bigger shop called Winstanley House stood at the junction with Plough Lane on the Victorian estate that previously occupied the area. In terms of Battersea's public housing projects, the present Winstanley estate is second in size only to the Battersea Park Road developments and, perhaps more surprisingly, was awarded an RIBA medal for good design in 1967.

St Peter's Church/Winstanley Estate

Built in 1875/76, the church at St Peter's was distinctive for its tall spire. By the time the Winstanley estate was replacing the original Victorian streets in the 1960s, the church had fallen into disuse. The body of the church was badly burnt in a fire started on Guy Fawkes Night 1970 by children playing with fireworks and it was demolished, leaving only the tower, until it too was pulled down in 1994. After more than forty years in makeshift premises, a new church is currently being built on the site, but for now the view today across York Gardens is of Sporle Court instead.

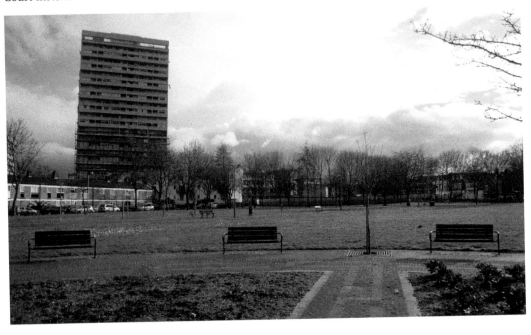

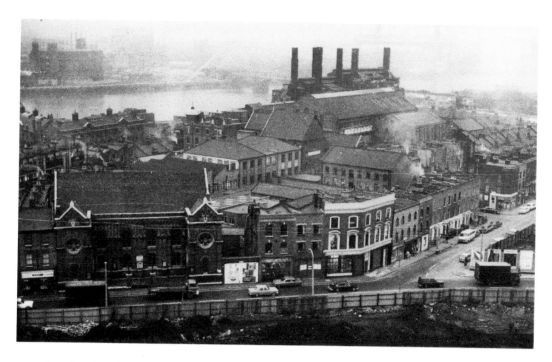

Baptist Church, York Road

A Baptist Meeting House reputedly existed in York Road from 1736, and probably even earlier. The first church was built in 1797 and the church here is the one that was rebuilt in 1870 and restored and reopened in 1956 following bomb damage during the Blitz. In the early 1960s it was compulsorily purchased by Battersea Council and demolished. In return a replacement chapel was built in Wye Street on the opposite side of York Road. Today the only pre-Second World War buildings that survive are the two 1860s houses to the right of the two commercial units in the centre below, on the corner with Yelverton Road.

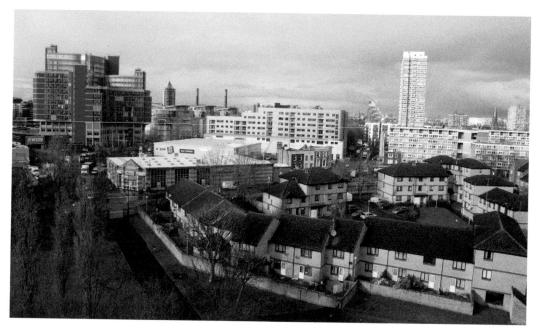

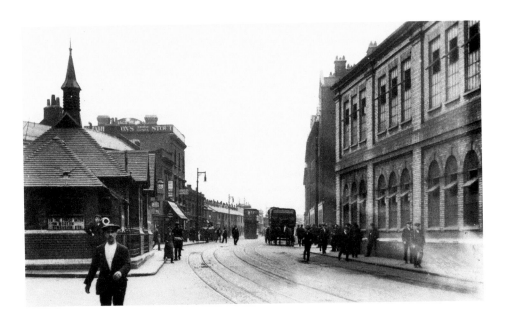

Price's Candles Factory

The Archbishops of York had a substantial estate in Battersea between the fifteenth and nineteenth centuries, including a manor house by the Thames at the mouth of the Falcon Brook, known as York Place. This became the site of enamel manufacturing in the area during the eighteenth century, until it was replaced in 1843 by the Price's Candles factory. By the end of the nineteenth century, the factory occupied 13½ acres between York Road and the Thames, employed 1,400 people and produced nearly 200 million candles and nightlights annually, winning many international awards. The advent of electricity led to a decline in demand for its products, and after a brief respite during the power strikes of the 1970s, production moved overseas and the site was sold to developers in the 1990s.

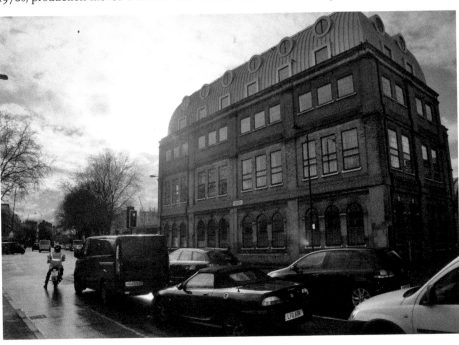

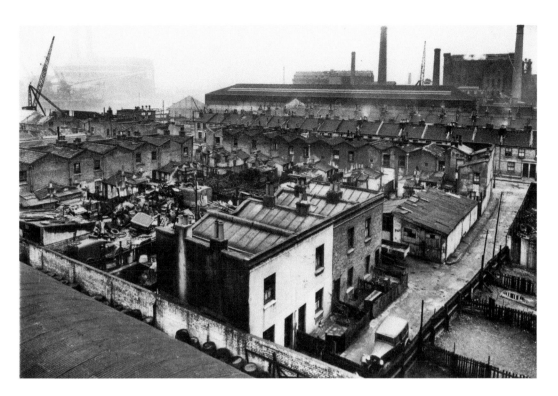

Mendip Road

The first houses went up in the mid-1840s, but it took a further twenty years for those on the west side to be built. They were intended for workers, and were very small with a frontage of just 12 feet, squeezed between a distillery, Price's Candles factory and the Garton sugar works. Renamed Chatfield Road, the original name is retained in Mendip Court, one of a thin line of waterfront apartment blocks that can be seen behind the low-level commercial frontage on York Road's northern edge.

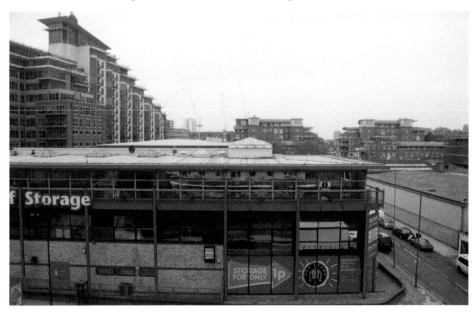

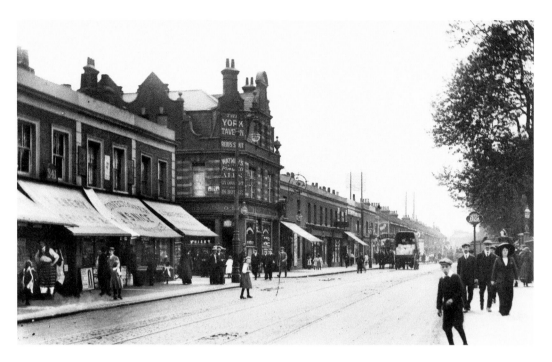

York Road (West)

The photograph above shows a thriving shopping street at the western end of York Road, with York Tavern on the corner and Usk Road rising clear of the two-storey buildings that lined the rest of the road. Usk Road is the only one west of Plough Road that extends from the south side of York Road beneath the railway line and up the slope to St John's Hill – although the underpass today is only open to pedestrians. Today, this stretch of York Road is congested and somewhat soulless, although the regeneration currently taking place offers hope for the future.

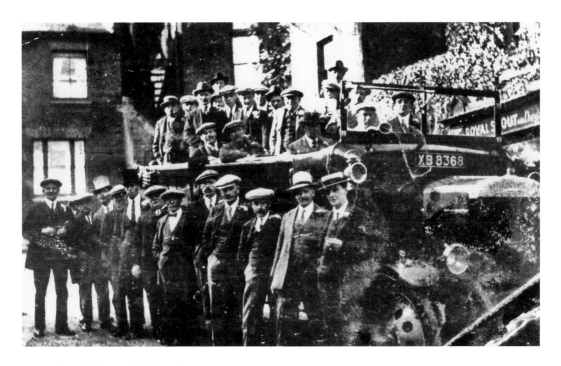

Somer's Arms, Usk Road

Dating back to the eighteenth century, the Somers Arms public house was squeezed into a chicane in Usk Road on the southern side of the railway lines, on the opposite side of the tracks to the truncated remainder of the road today. Much of the housing around it had disappeared by the mid-1970s, but the pub clung on. It was absorbed into the new developments that replaced those behind the old hospital further up St John's Hill, and redesignated No. 2a Rochelle Close. It finally closed in the 1980s and is recalled only in the name of the residential block that now has that address, The Optic. Note the contrast in the available modes of transport.

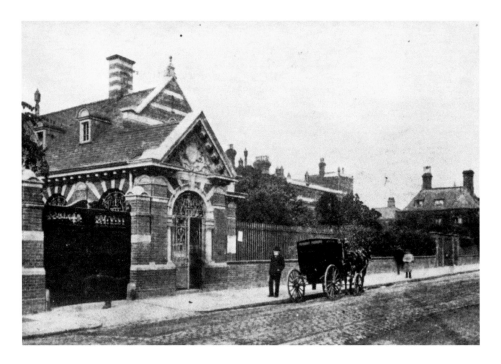

St John's Hospital/Centre, St John's Hill

A view of the Wandsworth and Clapham Union Workhouse, built in 1836. An infirmary was added in 1870 and served as a general hospital for the following 100 years. Some of the later additions to the hospital buildings survive, having been converted into flats, and can still be seen to the rear of the new St John's Centre, a therapy centre completed in 2007 that dominates the western end of St John's Hill.

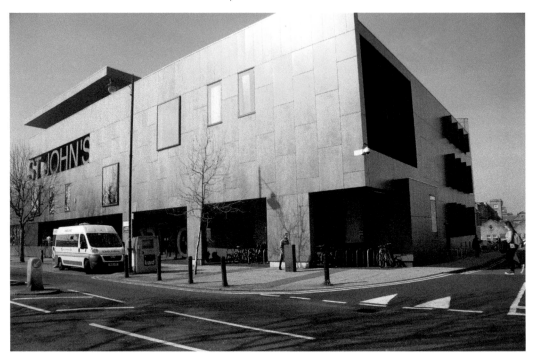

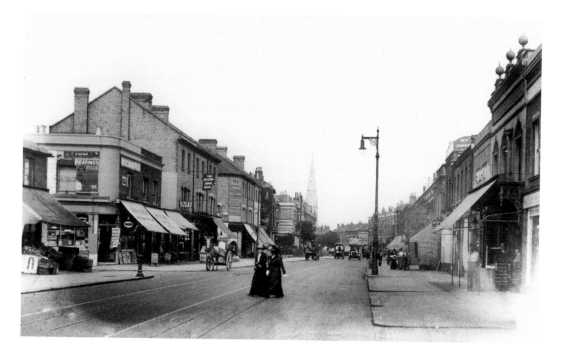

St John's Hill

St John (pronounced 'sinjun') was the surname of the Viscounts Bolingbroke, Lords of the Manor of Battersea and Wandsworth from 1627 until 1763 when they sold their interests to Earl Spencer. The shop frontage followed hard on the heels of the residential developments to the north and south of the main road and was largely established by the end of the 1860s. By this time, Clapham Junction had opened and larger stores began to gravitate around the new station, leaving St John's Hill as it is today with a wide variety of small, independent shops, bars and restaurants.

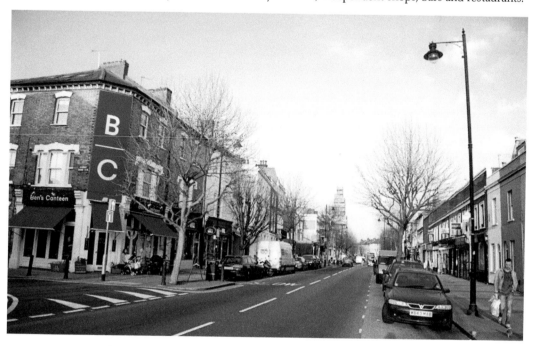

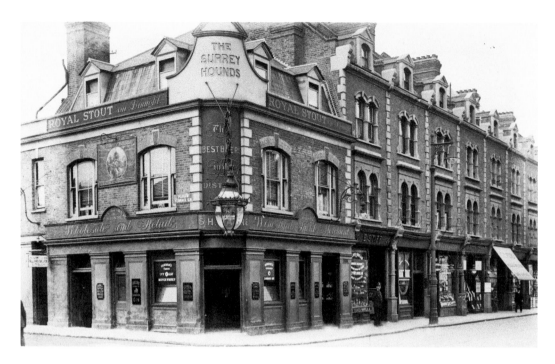

The Surrey Hounds, St John's Hill

The pub was badly damaged on 17 June 1944 by a V1 flying bomb. A neighbouring row of shops was partially destroyed in the same incident, and two passing trolleybuses were wrecked, causing heavy casualties. The pub was never rebuilt. Instead, council flats were built in 1949–51 next to the site, which is today a modern apartment block housing – ironically enough – a replacement window company at street level.

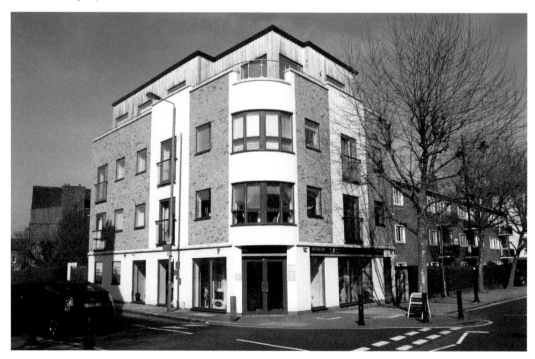

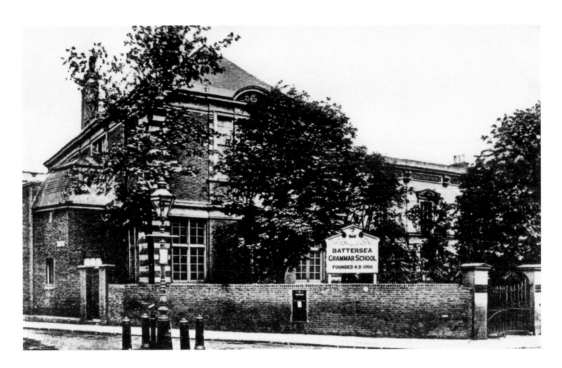

Battersea Grammar School/Granada Cinema, St John's Hill

Part of the St John's School foundation, Battersea Grammar School was opened on St John's Hill in 1875 on the site of St John's Lodge. After the Battersea Grammar School relocated to Streatham in 1936, the school buildings were demolished and replaced the following year with a Granada cinema, the third largest in the UK and a lush, heavily mirrored affair with a large Wurlitzer organ in front of the stage. Reflecting changing tastes in popular entertainment, it was converted in 1980 to a bingo hall. After this closed in 1997, the building was unoccupied for fifteen years until it was finally developed into flats in 2012.

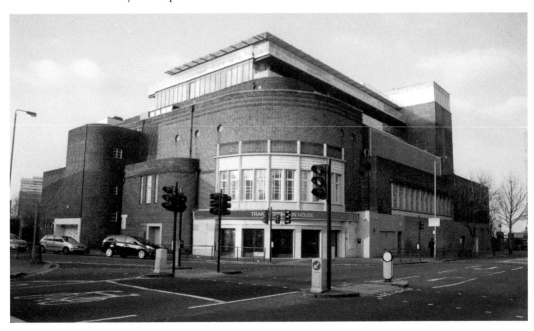

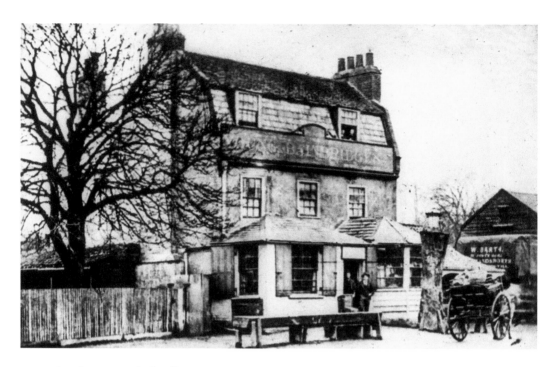

Plough Inn, St John's Hill

The Plough Inn was first mentioned in 1681 but is probably older. It was built to cater for travellers riding the country roads from the South West to the City of London. At the time, the pub commanded unimpeded views over Lavender Hill, Wandsworth Common and north towards the Thames. As the name on the hoarding over the first floor shows, this was the pub that was rebuilt in 1875/76 for Young & Bainbridge of the Ram Brewery in Wandsworth. It was bombed during the Second World War, and the modest two-storey brick building that went up in 1958 was replaced with this much bigger pub with residential flats above in 2011.

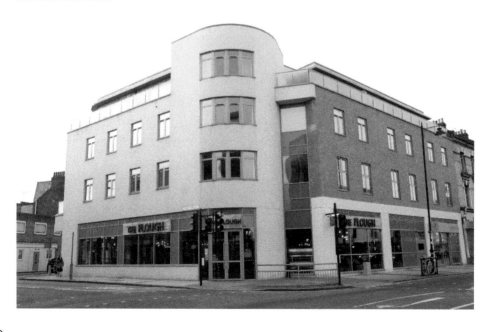

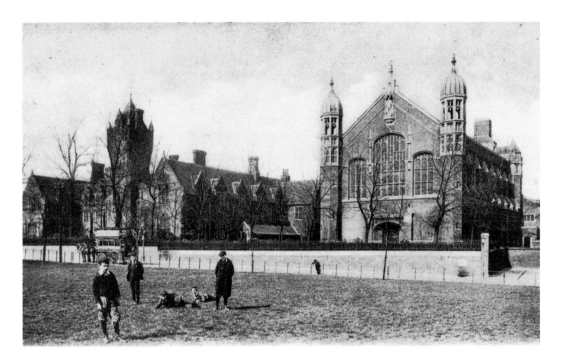

Royal Masonic School/Peabody Estate, Boutflower Road

The school for girls moved from its original home at St George's Fields in the city in 1853 to the healthier environment of Boutflower Road, on the edge of Wandsworth Common, where it remained until 1932. The imposing red-brick Gothic building with its central clock tower housed about 160 girls. Over time, however, the expansion of the nearby railway station encroached upon the area and the school moved to a new site in Rickmansworth in 1934. The Peabody Estate was built in its place in 1936, part of which is being currently being redeveloped to provide 527 homes at a cost of £120 million.

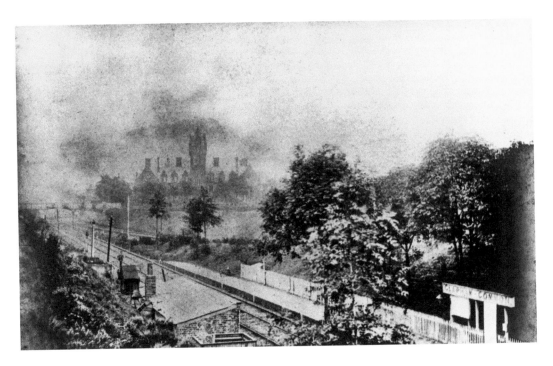

Clapham Common Station, Battersea Rise

In 1838, the London & Southampton Railway opened its station on Battersea Rise, which it first called Wandsworth and then, from 1844 (and equally misleadingly), Clapham Common, thereby perpetuating a deceit that continues to this day with Clapham Junction. The Royal Masonic School can be seen dimly in the background. It closed when Clapham Junction opened in 1863 and consolidated the local railway stations. Exactly 125 years later, on 12 December 1988, a multiple train collision occurred close to where the old station stood in which thirty-five people were killed and almost 500 injured. A memorial to the Clapham Junction rail crash stands on the other side of the tracks at the top of Spencer Park (Road).

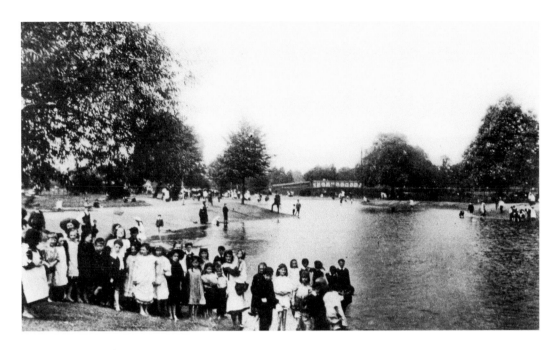

Wandsworth Common

Unlike Clapham Common with its powerful residents to defend it, Wandsworth Common was roughly halved between 1780 and 1860 through piecemeal sales by the Earls Spencer. Roads and then railways also sliced away at its edges. Thereafter, public protest and parliamentary legislation preserved the almost 200 acres that survives today. The 'Cat's Back' footbridge, visible in the distance in the photograph above, dates from 1893 and remains the only crossing over the railway lines along the entire length of the common. Where once children played in the water, today they are exhorted to keep out of it and seem content merely to record the wildlife that has taken their place.

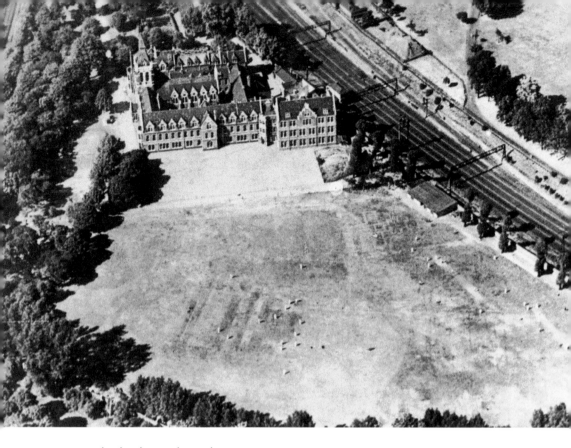

Emanuel School, Wandsworth Common

After almost three centuries near Tothill Fields in Westminster, in 1884 Emanuel School moved to its present location at the top of Wandsworth Common, squeezed between the two arms of tracks running south from Clapham Junction. The building was originally built for the Royal Victoria Patriotic School for Boys, an orphanage for the sons of soldiers and sailors killed on service and the 'brother' institution to the earlier School for Girls next door in Wandsworth. Today, it is Battersea's largest private secondary school.

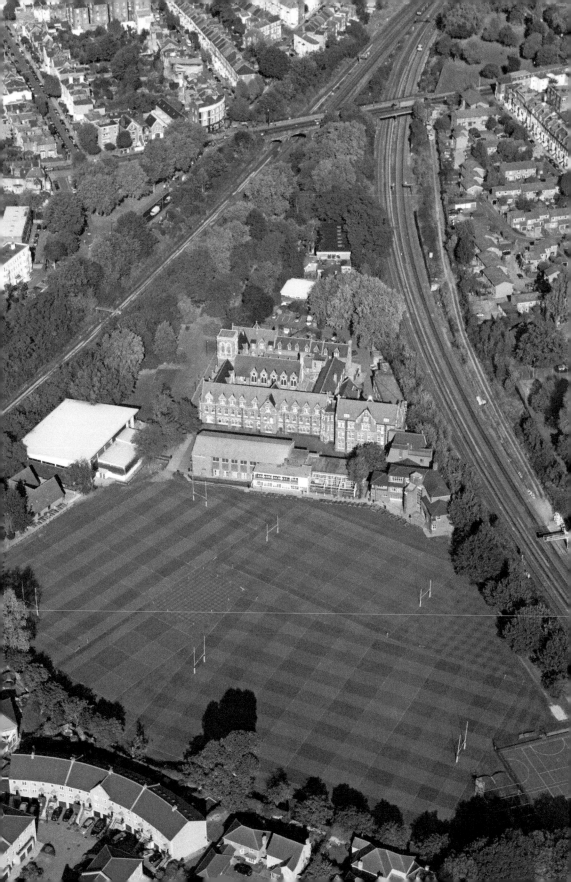

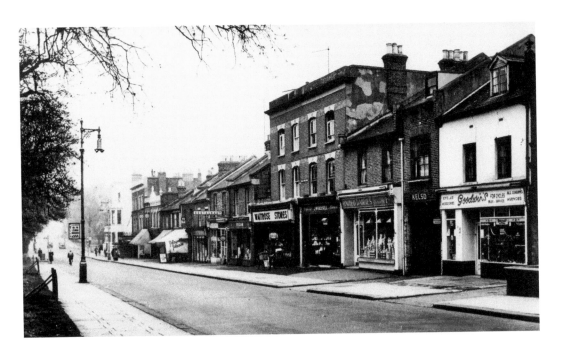

Bellevue Road

Originally just a track across Wandsworth Common, Bellevue Road has become the 'High Street' for the south-west corner of Battersea, an upmarket mix of cafes, restaurants and specialist shops – most notably the Michelin-starred Chez Bruce. The residential area behind the line of shops was also once part of the common before it was enclosed in the early 1830s. In spite of a few modern developments, the buildings retain much of their original charm and character.

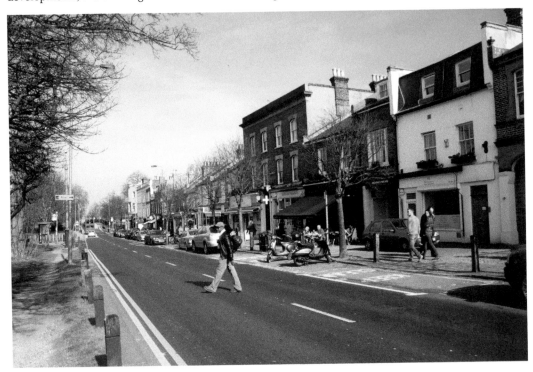

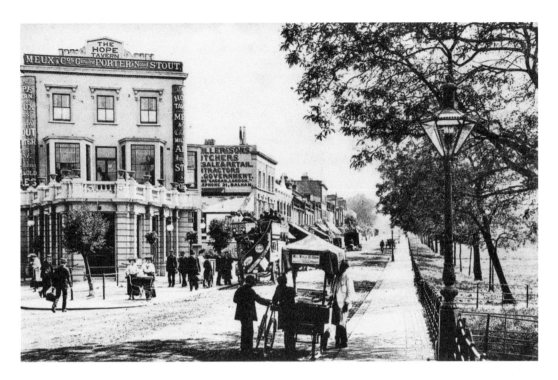

The Hope Tavern, Bellevue Road

The Hope Tavern was the first building to be erected on Bellevue Road, in the mid-1860s. Standing at the apex with St James's Drive and opposite the future site of Wandsworth Common railway station, it served the rapidly growing numbers of travellers into the area. A summer's day will see it similarly mobbed today by sun worshippers on Wandsworth Common seeking refreshment.

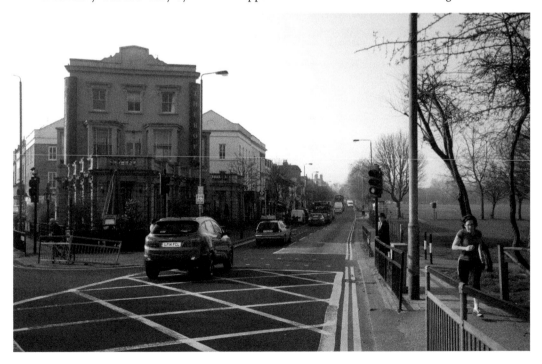

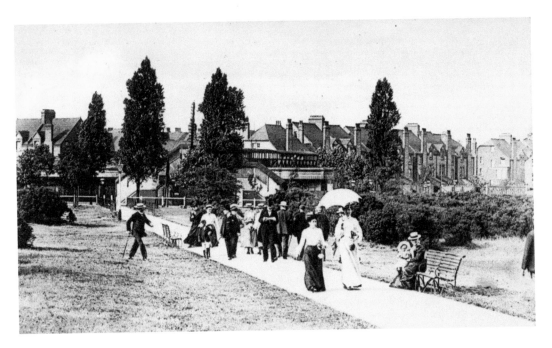

Wandsworth Common Rail Station, St James's Drive

The West End of London & Crystal Palace Railway opened a temporary terminus just north of the present station in 1856. This closed in 1858 but a new Wandsworth Common station – the one we see here today – was opened on the same day as Clapham Junction. The original station office survives today in Jaggard Way, on the far side of the tracks. The path in the photographs leads to St James's Drive and until 1988 to St James's Hospital, an industrial school that subsequently became a workhouse, infirmary and eventually a general hospital. It was demolished in 1992 and a new housing estate built on the site three years later.

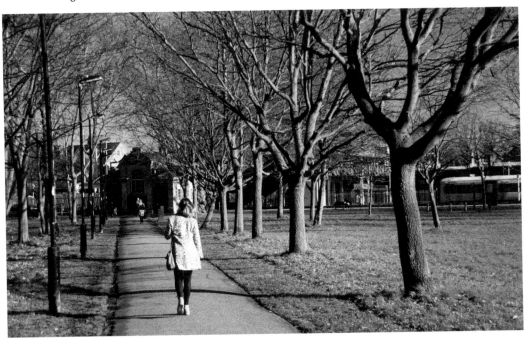

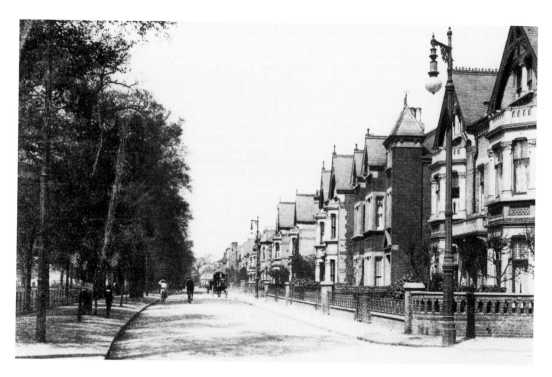

Bolingbroke Grove

It is difficult to believe from the seemingly endless row of houses that today faces Wandsworth Common that this road was originally known as Five House Lane on account of the five eighteenth-century villas that were the only buildings along its entire 1-mile length. By the mid-nineteenth century, the road was generally known by its present name, taken from the largest of the five former houses that survived as part of the hospital further along the road until its demolition in 1937.

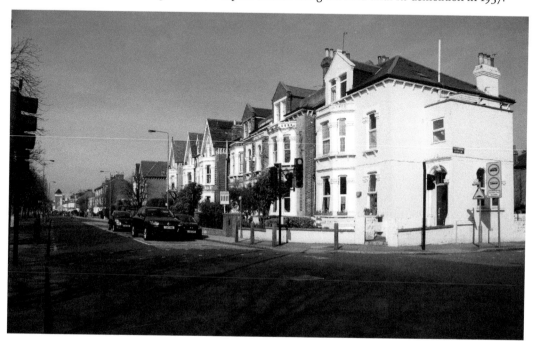

89

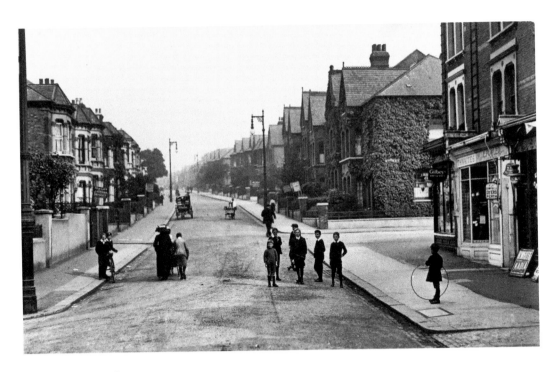

Broomwood Road

The name derives from Broomfield, the home of William Wilberforce, the slavery abolitionist, upon whose estate this and several of the neighbouring roads were built. A plaque on the house at the corner with Wroughton Road commemorates the original house and Wilberforce's earlier connection with it. Building work here in the early 1880s triggered the spread of housing around the south side of Clapham Common at the end of the century. The road is now a busy bus route into central London for the area's wage slaves.

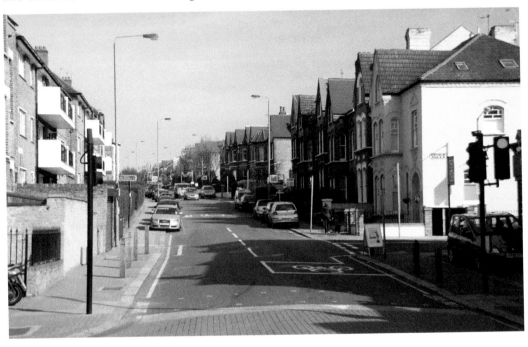

Thurleigh Road

Developed on fields originally attached to Old Park mansion, the houses here are characteristically larger and in more spacious grounds than their tightly packed terraced neighbours to the north – the direct consequence of a covenant that only detached or semi-detached houses could be built there. The tower in the distance is that of St Luke's church, the original building of which was constructed from the iron church that had previously served as a temporary venue for St Mark's on Battersea Rise. It was replaced with the structure we see today, which was consecrated in 1892.

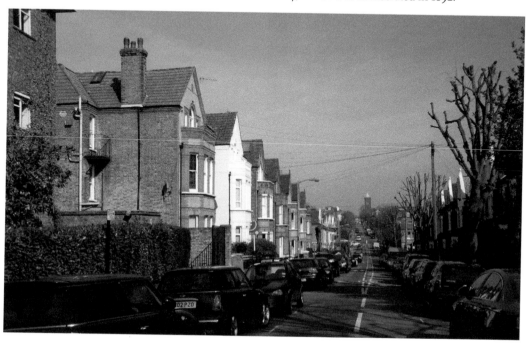

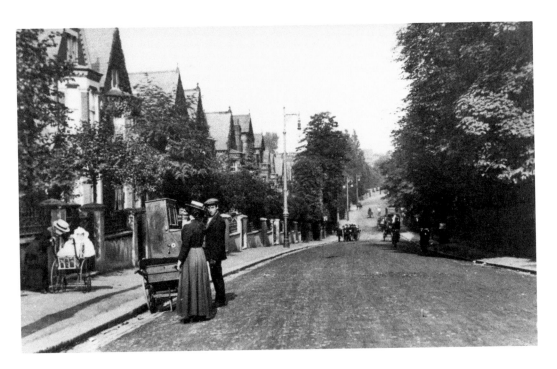

Nightingale Lane

Nightingale Lane demarcates Battersea's southern boundary and runs between Wandsworth and Clapham Commons. A few new developments have encroached along its length but, like Thurleigh Road, many of the earlier, large detached and semi-detached villas survive to this day. A Blue Plaque at No. 40 Nightingale Lane commemorates the humourist and cartoonist H. M. Bateman, who lived here as a young man. It is easy to imagine that he drew inspiration from the sights and manners of the suburban middle classes in the surrounding area.

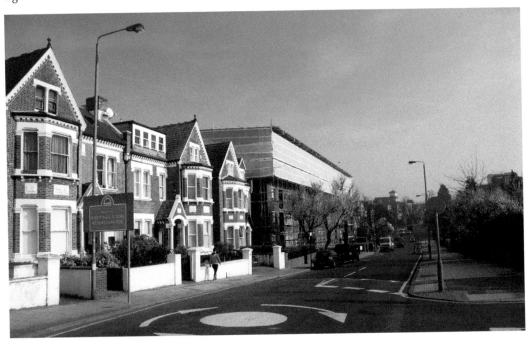

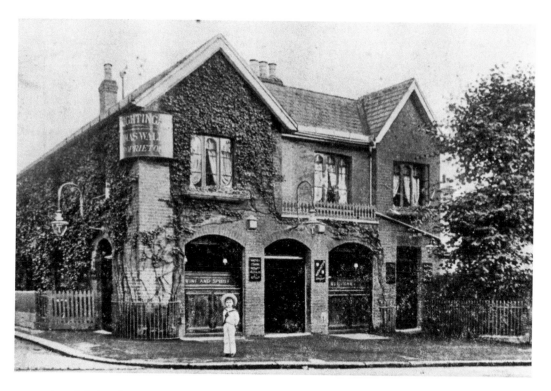

The Nightingale, Nightingale Lane

A young boy in late Victorian clothing waits outside The Nightingale public house. Built on the Old Park estate in 1853, The Nightingale is a mid-Victorian cottage style pub and Grade II listed building. Today, The Nightingale is the home of the Nightingale Walk, which has been raising money for charity since the 1980s. Other recent accolades include 'Britain's proudest pub' and 'the greenest pub in London'.

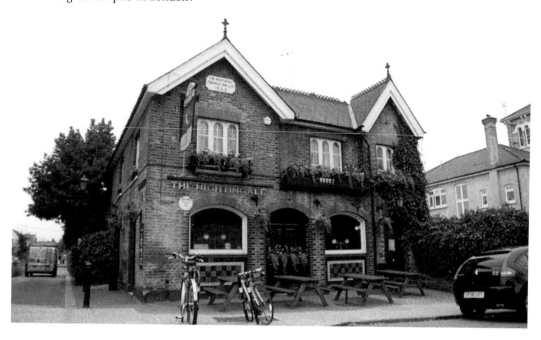

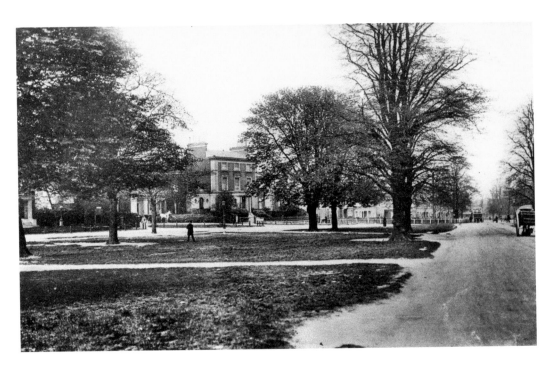

Clapham Common, West Side

Wealthy businessmen first started to move to Clapham Common in the mid-eighteenth century. Perched overlooking meadows and woods, it would have been a welcome respite from London's dank, dirty streets. By the mid-nineteenth century, however, the area was being given over to more modest middle-class housing and this substantial, detached early Victorian house, erected in 1858/59, was the last of the large, private villas to be built between the commons. Originally called Heath View, it became a private club from 1965, but fell into disuse until it was recently bought (for about £5 million), since when it has been extensively renovated.

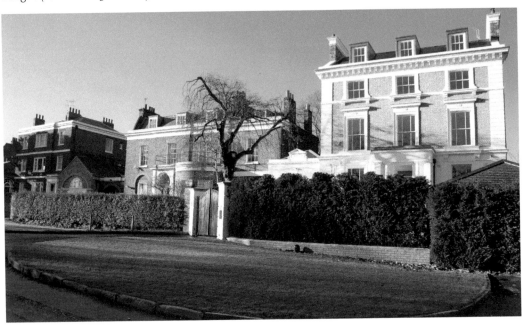

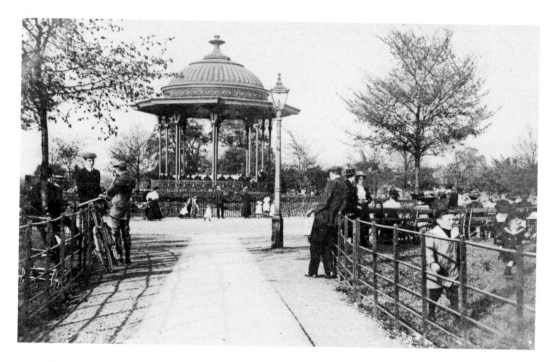

The Bandstand, Clapham Common

At 220 acres, Clapham Common is slightly bigger than both Battersea Park and Wandsworth Common. Like the latter, however, Battersea's boundary runs down the middle of Clapham Common. At the centre of the Common, and over the ditch from Nightingale Lane to Wix's Lane on the north side that marked the parish boundary more than 400 years ago, stands the Bandstand. It was copied from a pair built in 1861 for the Royal Horticultural Society's garden in South Kensington and erected on the Common in 1890. Its use today is presumably very different from that envisaged by its creators.

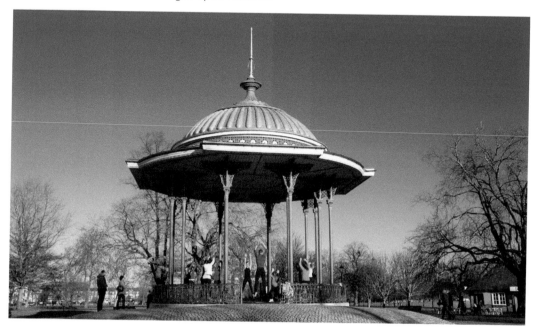

Acknowledgements

The sources of information for this book include Patrick Loobey's *Battersea and Clapham* selections, and *Battersea Past,* which he edited, *We Served: War-time Wandsworth and Battersea, 1939–1945* by Anthony Shaw and Jon Mills, *The Streets of Battersea: Their Names and Origins* by Keith Bailey, and the *Survey of London: Battersea (volumes 49 & 50)*, edited by Andrew Saint and Colin Thom. Ruth MacLeod and Gillian McGrandles at Wandsworth Heritage Service also provided much invaluable information and support.

The authors would also like to thank David Atkinson, Len Bridge, Michael Hamilton, Fred Hammond, Tony Jones, Tim Taubman, Helen Taylor, Sven Tester and the Wandsworth Historical Society.

Image Credits

Old images courtesy of the following people and organisations:

Emanuel School: pages 84, 85.

Roger Armstrong: pages 7, 39, 75, 93.

Ron Elam: pages 5, 6, 8, 9, 10, 11, 12, 15, 16, 20, 23, 26, 28, 31, 33, 34, 37, 42, 43, 46, 48, 50, 51, 54, 55, 59, 64, 66, 67, 72, 74, 77, 81, 83, 86, 87, 88, 89, 90, 91, 92, 94, 95.

St Mary's church: pages 22, 25, 30, 32, 40, 44, 47, 49, 53, 58, 68, 79.

St Peter's church: page 70.

Wandsworth Heritage Service: pages 13, 14, 17, 18, 19, 21, 24, 27, 29, 35, 36, 38, 41, 45, 52, 56, 57, 60, 61, 62, 63, 65, 69, 71, 73, 76, 78, 80, 82.

All modern images taken by Simon McNeill-Ritchie (except modern image on page 83, courtesy of Emanuel School).